John Tusa is Chair of the Clore Leadership Programme in the arts. His many senior positions in journalism and the arts have included Managing Director of the BBC World Service (1986–92) and of the Barbican Centre in London (1995–2007), and Chairman of the University of the Arts London (2007–13). Before moving into arts management, he was an award-winning BBC TV and radio journalist, most notably for the BBC's *Newsnight*. His books include *Art Matters* and *Engaged with the Arts* (I.B.Tauris, 2007). John Tusa was knighted in 2003.

'I have always admired John's fearless pursuit of clarity, and this book is a dose of smelling salts thrust under the nose of the body cultural. He has a great instinct for coining or spotting the telling phrase that cuts through the fog of obfuscation and self-delusion that so often cloaks arts policy. His analysis of the often-unconsciously deceptive language used around arts organisations is as amusing as it is timely. He is a champion of the arts who unusually is able to combine a celebratory love of its productions with unflinchingly honest appraisal of its organisations.'

Grayson Perry

'It's essential this book is read by anyone in the arts or passionate about the arts. As the inspirational director of the Clore Leadership Programme, he is nurturing the talented young people who will ensure this country continues to have world beating arts and culture. His writing is wise, insightful… and fun.'

Tony Hall
Director-General of the BBC

'The arts are necessary and important. They have been doing well in the UK but will undoubtedly face some big challenges in the future. Clear thinking and strong leadership will be required. John Tusa, characteristically articulate and provocative, provides a real stimulus for the thinking which is needed.'

Vernon Ellis
Chair of the British Council

'This is an important book: not only for its page-turning personal account of turbulent times, but also in the insights and challenges offered – reminding all who work in the arts of the need to be sure of our first principles and to defend them resolutely.'

Alan Davey
Chief Executive, the Arts Council

'Simultaneously arts boss and iconoclast, John Tusa is a lifelong scourge of meddling politicians who think the arts are Covent Garden and that targets make good symphonies. His third book on the subject, the fruit of his own years running the Barbican and the Clore Leadership Programme, is brilliant on the way artists got to grips with the managerial culture of the Blair years, learnt its good skills and then turned its arid instrumentalism on its head. Essential reading for any council contemplating scrapping its culture budget.'

Liz Forgan
Former Chair, Arts Council England

JOHN TUSA

PAIN IN THE ARTS

I.B.TAURIS

LONDON · NEW YORK

Published in 2014 by I.B.Tauris & Co Ltd
6 Salem Road, London W2 4BU
175 Fifth Avenue, New York NY 10010
www.ibtauris.com

Distributed in the United States and Canada
Exclusively by Palgrave Macmillan
175 Fifth Avenue, New York NY 10010

ISBN: 978 1 78076 817 5
eISBN: 978 0 85773 476 1

A full CIP record for this book is available from the British Library
A full CIP record is available from the Library of Congress
Library of Congress Catalog Card Number: available

Text designed and typeset by Tetragon, London
Printed and bound by CPI Group (UK) Ltd, Croydon, CR0 4YY

CONTENTS

Acknowledgements ix

Preface xi

Part I · Getting Things Done

1 Pain in the Arts: Decline or Renewal? 3

2 Surviving the Downturn 16

3 Looking Facts in the Face: The Case for the Arts 26

4 The Dos and Don'ts of Running the Arts 37

5 The Wars of the Words: Language Matters 52

6 Learning on the Job: A Personal Road to Responsibility 64

7 The Leader, the Manager: What's the Difference? 74

8 What Do You Know? Inside the Mind of a Leader 87

9 An Arts Policy for a Floating Utopia 98

10 Keeping It Simple 103

Part II · Arguing for the Arts

11 The State of the Arts, the Arts and the State 109

12 Music All Around Us 128

13 The Education Debate: Giving the Young the Arts They Deserve 148

14 The Arts: A Special Case for Special Pleading 168

15 The Arts and Civil Society: Firm Friends or Distant Cousins? 188

16 Small Is Significant: Taking Care of the Roots 206

Index 235

This book is dedicated to
Fellows of the Clore Leadership Programme
past, present and future

ACKNOWLEDGEMENTS

During the last six years I have been deeply involved in the chairing of the Clore Leadership Programme. Much of the book springs from the thinking about leadership in the world of culture that the programme engages in. My gratitude goes to Dame Vivien Duffield, founder and key funder of the Clore Leadership Programme, for trusting me with the responsibility of working so closely with several hundred of the nation's present and future cultural leaders and influencers. It has been a profound and inspiring experience. Sally Bacon, director of the Clore Duffield Foundation, has been a strong and encouraging support throughout.

I have been fortunate to work with Sue Hoyle, the best and most dedicated of colleagues, director of the programme, and a small and incredibly committed team, Fiona Cameron, Sharon Armstrong-Williams, Rebecca Laschetti, Alisha Whittington and Maria Schweppe. Their generosity of spirit, tolerance, wisdom and understanding are admirable to observe and explain how the leadership programme can so effectively be a 'learning' experience, far richer, far deeper, far more profound than merely an experience that is taught. William Warrener has added to his normal commitments by providing speedy and accurate research assistance.

The book also ranges widely over the major events in the national arts and cultural scene of the last six years. Simon Tait, co-editor of the invaluable *Arts Industry* magazine, gave me access to his back files. Some chapters were read by John Newbigin, John Holden, Vikki Heywood and Sue Hoyle. I am grateful to all for their time and their observations.

I would also like to thank Anthony Thwaite for granting me permission to quote from 'For Louis MacNeice' from *Collected Poems* (Enitharmon Press, 2007).

My gratitude too to the 250 plus Clore Fellows, with the majority of whom I have had personal contact: humorous, honest, funny, revealing, surprising, disturbing, but always thought-provoking. Some are already changing the nation's arts world. But the learning experience has been mine too. I cannot thank them enough. This book is therefore dedicated to Clore Fellows, past, present and future.

From the beginning, my publisher Iradj Bagherzade had a strong sense of what the book might be. His persuasive comments were well judged. I cannot thank my editor at I.B.Tauris, Philippa Brewster, adequately. Throughout she has suggested, cajoled, guided and occasionally insisted; her advice has been gladly accepted and put into practice. My copy-editor, Alex Middleton, has applied a shrewd mind and microscopic eye to the entire text. Needless to say, the final responsibility for what I have written is mine alone.

Finally to my wife, partner and friend, Ann – feelings beyond thanks, love and gratitude. Admiration.

Islington, November 2013

PREFACE

This book is based on life since stepping down from the Barbican in 2007 and becoming chairman of the Clore Leadership Programme in 2008. It is written at a time when the arts nationally have reached a peak of achievement but face deep cuts whose consequences are incalculable. I concentrate in part on the increasingly complex questions – financial, practical, political, personal, professional – that crowd in on today's cultural leaders. I also engage directly with many of the major controversies that have faced the arts during recent years. I examine the debates that raged with New Labour over the alleged 'instrumental' purposes of the arts. I argue that a wise government – of any colour or persuasion – would simply not bother to cut arts funding at all. I explain why a secure and central place for arts education in our schools is an effective way of enhancing education. I also draw on my diary of these years to paint a picture of the arts world as it evolved and as I experienced it, for good or ill.

I believe that defence of the purposes and needs of the arts is a continuous task; I believe that it must be conducted robustly and sensitively, but without apology; I believe the words and language used in their defence must be ours and not the language of business; I believe that the value of the arts in society is huge, that their benefits are still underestimated; in these pages, I try to make the case as strongly and effectively as I can.

This is the third book I have written on how the arts are run, on why they are worth running and defending, and on the assorted pleasures and pains of trying to run and speak up for them. The first two books – *Art Matters: Reflecting on Culture* (Methuen, 1999) and *Engaged with the Arts: Writings from the Frontline* (I.B.Tauris, 2007) – were based largely on my experiences

as managing director of the Barbican Centre from 1995 to 2007. *Pain in the Arts*, heavily influenced by my experiences with the Clore Leadership Programme, comes from a somewhat different personal standpoint where the contemporary needs and practices of leadership and constant polemical engagement have run in parallel. What I believe they all proclaim is my unwavering belief in the value of the arts and my unappeasable relish in their enjoyment. I cannot imagine a life without them. I am certainly not alone in feeling this way.

Part I

Getting Things Done

1

PAIN IN THE ARTS: DECLINE OR RENEWAL?

'Arts organisations are going to close and the impact locally is going to be devastating.'

Regional arts leader

'Why do British ministers meet anyone from the arts other than to cut them?'

Anish Kapoor, sculptor

As the world of arts and culture in Britain moves towards the midpoint of the second decade of the twenty-first century, it is beyond argument that it will suffer pain – for some organisations severe, perhaps terminal pain. For many, perhaps most, there will be the prospect of severe retrenchment or reorganisation. For all, large or small, metropolitan or regional, the question of responding to adversity is larger and more complex; even its actual nature and exact outlines are difficult to sketch. Clearly, times will be hard until at least 2018.

The arts world already knows something of its future with reduction of its public funding and does not like what it sees; it is uncertain about its capacity and resolution to live in these more restricted financial circumstances; it is openly fearful about the entire environment in which it will work; it is in particular anxious about the full consequences of the withdrawal of much local-authority support. Are the severe reductions in publicly funded support the inevitable prelude to pain and decline for

the arts? Could they catalyse a transition to new structures, new relation-ships, even a new profile for the arts in national society and the economy? To ask such questions is not to indulge in glib optimism or vapid talk of 'challenges'. It is to believe that the existing intellectual strength, variety, plurality and cohesiveness of the arts ecology is capable of facing up to a bad situation and making something better from it. One part of the answer will be determined by the existence of new generations of arts and cultural leaders, dedicated to and knowledgeable in the arts them-selves but equipped with the many skills and disciplines that make arts management today such a dynamic, professional and effective – though demanding – activity.

A generation ago or even less, had it been suggested to the director of any major national museum or gallery that he or she was a 'cultural leader', he or she would have blinked and replied: 'I am a scholar; I am a historian; I am a keeper and curator. That is what matters. I leave the rest to my head of administration. Isn't that right? As for being a cultural leader, I don't really understand!' He or she would have been right at the time. Today's museum directors, theatre heads and opera chiefs are no less devoted to, and expert in, their particular art forms. Beyond that, they accept and fulfil a range of responsibilities previously considered irrelevant or inconceivable. Such a change of approach amounts to a revolution in the ways that the arts run themselves. This book is about that revolution in arts leadership, its nature, its demands and what it might achieve when wholeheartedly carried out.

The financial outlines of the funding cuts were very clear: a 15 per cent reduction in funding to so-called 'front-line' organisations in October 2010; as if that were not bad enough, a further 5 per cent cut in June 2013. The fact that the added 5 per cent cut was greeted with relief because it 'might have been so much worse' could not alter the fact that these amounted to big reductions in national-government funding of the arts. They could not be shrugged off. How they were seen and what effect they would have triggered a raging debate between politicians and arts leaders.

JOINING THE DEBATE

During 2013, three voices from the heart of the arts establishment defined the issues at stake. They did so in plain, even blunt terms. Taking on the government publicly in any field is never easy, especially in the arts. Doing so involves personal as well as institutional courage. Nobody, in or outside the arts, should underestimate the bravery required to do so. The fact that these three choose to speak out so openly pointed to their sense of the acute nature of the crisis facing the arts. They spoke because they felt they had no choice. As she stood down from the chair of Arts Council England, from which the then culture secretary, Jeremy Hunt, had unceremoniously ejected her, Dame Liz Forgan calmly laid out the rational case for not treating the arts as if the sums devoted to them were matters of life or death for hospital patients or the future of our children's education. The arts receive just half of one-tenth of a per cent of the national budget – 0.05 per cent. 'Any saving,' argued Forgan, 'is far too tiny to make any impact on the serious challenges in the national budget and the damage is deep and lasting.' This may now almost be a truism on the arts side of the great funding debate, but it is a necessary truth that needs stating and restating.

Tactics are always important in the great arts debate. Forgan chose to concentrate on the big picture: the arts cost nothing; they do huge good. She decided not to become personal, not to criticise the Department for Culture, Media and Sport (DCMS) or the Secretary of State head-on; that would have looked like bitterness – probably justified – at the way Hunt pushed her aside after a single term in office. Instead she switched her target, cannily choosing to call out the education secretary, Michael Gove, and challenge him to own up publicly to what everyone knew was the case – that as someone well known for attending arts events he is an arts supporter – to say as much and to match words with deeds by restoring the arts to a core place in the school curriculum. 'It is no good saying schools are free to teach music and art if they want to and the pupils insist,' argued Forgan. 'If those things are not in the core of the state examination system, a big red signal is hoisted saying with total clarity: "This is of secondary importance. We don't care!"' Shrewd as the tactic

was, Gove declined to be flushed out, choosing not to reveal himself as a closet arts lover, itself an indicator of the low standing the arts enjoy in Whitehall rankings.

RIGHT AT THE EDGE

Others have been more frontal in their approach. With his departure from a highly successful tenure of the Royal National Theatre announced for 2015, Sir Nicholas Hytner is recognised as a very modern cultural leader, combining creative excellence with commercial entrepreneurship, technological innovation and audience-widening in a balanced and effective way. His right to warn of an arts future savaged by reduced public support came from this entirely earned and crafted modern position as a rounded arts leader. When he criticised the new culture secretary, Maria Miller, for not defending the arts adequately, he did so not in the special interest of his own theatre – no one could criticise him for that in any case – but in the interest of regional theatres throughout the country. 'We are facing the same situation as we endured between 1979 and 1992 when 25 per cent of regional theatres closed down. […] We are right at the edge. It's the clear truth, I know.'

Hytner was heavily critical of Miller's predecessor, Jeremy Hunt, whose 'emollient rhetoric' on the arts did not stop him from acquiescing in a 30 per cent cut in the arts. Here Hytner was reminding the arts world that lying low and keeping quiet during a political dogfight seldom bring results. And he challenged the role that a culture secretary should play in the national and political debate about arts support, especially one who spoke dismissively of the 'arts lobby' and declared that the public 'wouldn't wear' an increase – or even a freeze – in arts funding.

For Hytner,

> To be blunt, it is [Miller's] job to join with us and reassure the electorate […] After the success of the past 15 years, after the way community arts have flourished […] I think there is widespread support for the idea of a modest investment in the arts

[…] You don't spend nothing on your child's birthday because it's an untenable luxury. It's necessary to accept that a balanced budget is necessary for a balanced life, and the same applies to the nation as a whole.

In arguing as he did, Nicholas Hytner focussed on two key issues about the arts world's expectations of culture secretaries. The first was that it expected its representative at the Cabinet table to know about the arts, to value them – not uncritically – and to make the case for their support. After all, if the culture secretary would not speak up, who else would?

Margaret Thatcher's attitude to the arts was famously parodied in *Yes Minister* as follows: 'The Ministry of Agriculture stands up for farmers; the Department of Health stands up for doctors and nurses. And the Foreign Office? Of course, they stand up for foreigners.' It never occurred to her or her successors to warn that the culture secretary 'stood up for the arts'. In fact it is highly debatable whether the arts world has had a truly supportive culture secretary since Chris Smith in the late 1990s.

The confidence deficit in Maria Miller's actual valuation of the arts reached its peak in mid 2013 when *The Times* wondered if she should not properly be called the 'anti-arts culture secretary', a nadir in her professional standing. But Richard Morrison spelled out the details:

It would be reassuring to know that the culture secretary was fighting tooth and nail to safeguard Britain's superb cultural scene. Miller gives the impression that, actually, she isn't that bothered. Her approach so far as one can tell is that of an asset stripper. Preserve those bits of the arts that can generate profits and to hell with the rest. To her, subsidy can only be justified as 'seed money' that will reap economic benefits further down the line.

Whether these assumptions were exactly true or not, Morrison felt it necessary to lay down a reminder about the essential truth about the arts: 'The fundamental reason for spending taxpayers' money on culture is that it enriches lives.' It is possible that the arts will never be adequately

funded unless and until the possibility of that belief becomes a part of mainstream political dialogue.

CHOOSING TACTICS

But Nicholas Hytner was also raising a second basic issue: how should the arts position themselves in their public dialogue with politicians? In admitting that Jeremy Hunt was given the benefit of the doubt about his commitment to the arts – and much good it did them! – the matter remains unresolved. What tactics should be adopted? Constant controversy? Emollient optimism? Constructive dialogue? The balance between these positions has yet to be effectively struck, varies from arts leader to arts leader and shifts in line with the political wind. But the conclusion from the experience with Jeremy Hunt is that those in the arts world should never assume that their representative in the Cabinet at the heart of government is 'on their side'. Any Secretary of State for Culture, Media and Sport is only ever on the side of his or her own political advancement. The suggestion that he or she might have 'gone native' with a genuine concern for the arts would only appear as a black mark on his or her political and party record.

Do politicians pay any attention to public resistance from the arts? In 1999–2000, the self-styled 'Shadow Arts Council' was set up by Sir Peter Hall, Norman Rosenthal, then exhibitions secretary at the Royal Academy of Arts, and myself as managing director of the Barbican. It was a challenge to the ineffectiveness of the then Arts Council in speaking up for the arts in the face of funding reductions. We made a good deal of noise. We were rather unpopular. But Number Ten noticed and a proper debate began. Later ministers admitted that the very public demonstrativeness of the Shadow Arts Council helped them to make their case within Whitehall.

The third voice in the 2013 debate worth listening to came from a major artist; it usefully added an international perspective to the national conversation. As the British sculptor Anish Kapoor prepared his retrospective at the Martin-Gropius-Bau in Berlin in May 2013, he mused on the difference between Britain and Germany in the value each country puts on the arts:

In Germany, it seems that the intellectual and aesthetic life are to be celebrated and are seen as part of a real and good education. Whereas in Britain, traditionally, certainly since the Enlightenment, we've been afraid of anything intellectual, aesthetic, visual.

Here Kapoor was pinpointing the deep concerns surrounding the diminution of the role of the arts in education and the consequences for the value placed on them. If the arts are habitually treated and referred to as less valuable, less important, less worthwhile than other academic and learned disciplines, then any subsequent debate about supporting them in society at large becomes hog-tied with prejudice.

Kapoor ventured beyond broad philosophical observations. As a practical person, he made very practical observations:

In the UK, while the arts are the second biggest sector after banking, they probably form less than one-tenth of 1 per cent of government spending. It's completely scuzzy! The UK has two things, the arts and education, and both of them it pushes into the corner. It's the biggest, hugest mistake.

In making this point, Kapoor raged against the extraordinary, self-defeating national attitude where the government and the people undervalue, underuse and undersupport the very things that the nation excels at.

And the sculptor was not finished with the politicians. How at a personal level did they deal with the arts? Not well. 'Why do British ministers meet anyone in the arts other than to cut them?' He might have noted, as others have done, that the German chancellor, Angela Merkel, went to Bayreuth in August 2013 for the new production of Wagner's *Ring* cycle – by no means the first German chancellor to do so. By contrast, in 2012, both Chancellor George Osborne and Culture Minister Ed Vaizey sneaked into the Royal Opera House in London by back doors in order not to be 'caught' by the press attending performances of the *Ring*. In such a politically arts-averse culture, no wonder that a mature, honest debate is difficult, if not impossible, to conduct. That

is why robust, outspoken engagement with the politicians as expressed
by Forgan, Hytner and Kapoor is so essential. A non-stop public barney
achieves nothing. Determined defence of the arts world's positions is
quite another matter; without such a defence, the debate is not a debate,
just a lopsided monologue.

These exchanges were not one-way. When the culture secretary, Maria
Miller, set out her position after the government's spending review in
June 2013, she went on the attack. All talk of a crisis was 'laughable', and
those who engaged in it were personally responsible for 'dispiriting all
those who work in the arts'! This was an extraordinary claim to make
and an incredible one – those dispirited were so because of the cuts being
imposed by the coalition government.

Miller had to be essentially on the defensive, making much of the
claim that she was 'on the side of the arts' – which few believed – and
that she would fight for them politically – which fewer still believed.
A politician's weakest position on any subject emerges as they assure
the public that such and such an institution – typically the NHS – is
'safe in their hands'. If it needs saying then it carries no credibility. The
minister – whoever, wherever – 'doth protest too much'! Worse still,
Maria Miller built her position that she was defending the arts on the
narrowest of grounds, that of economic justification. Nothing could
demonstrate more clearly her inability – or refusal – to take in what
the arts world was reasonably proposing: a balanced, inclusive, broad
justification that embraced everything the arts did from the abstract to
the practical. It was worse than a dialogue of the deaf; it was clear whose
hearing was defective.

Not that it is impossible – or even difficult – to make the economic
case for the arts. It was the celebrated economist John Maynard Keynes
who founded the Arts Council; he was also active in the Political Economy
Club, which he began in 1909. Twenty of Keynes' distinguished succes-
sors from that group wrote to the *Guardian* in June 2013 arguing that the
economic case for the arts was indeed important but pointing out that
it already existed:

Broadly defined, commercial creative activities account for a for-
midable 10 per cent of national output [...] This country can ill
afford to neglect an area of such excellence that attracts the rest of
the world [...] Tourist spending and its knock-on effects amount to
at least 6 per cent of our national output; this is simply the most
obvious of the 'multiplier' benefits of the arts to the economy.

This from hard-nosed economists! Seldom has the economic justifica-
tion for investment in the arts been made so succinctly or with so much
authority.

The rebuke was clear: to the Secretary of State for calling for an
'economic' debate about the arts when the case already existed; to the
chancellor, George Osborne, and his Treasury team for ignoring evidence
about the economic value of the arts that existed squarely in their books;
to the prime minister, David Cameron, for choosing not to mobilise the
good arguments so easily available in a national campaign of persuasion.

It was possible, though, for someone holding the post of culture
secretary to think, argue and act very differently from the English one's
narrow economic obscurantism. In Scotland, Fiona Hyslop set out the
Scottish National Party's views on culture in June 2013. 'It roots us in place,
and helps to empower, enrich and shape our communities.' Hyslop was
talking the language of identity, values and the human spirit, claiming
that those things were intrinsic to arts activity and the grounds for its
political support. Would such beliefs ever permeate the far narrower
English political debate on the arts?

What these year-long exchanges highlighted throughout 2013 was
the extent of the breakdown in communication between the arts and the
world of politics. Ministers understood and valued neither the richness
and complexity of the way the arts world worked nor the strength of the
case to be made for supporting it. The prevailing Whitehall culture and its
media presentation had long taken it as an article of faith that supporting
the arts at best gained few votes and at worst lost some. Identification
with the arts was judged to invite accusations of remoteness, detachment,
lack of understanding of the lives of others and general elitism. With

such feeble foundations of understanding and support for the arts, it was completely unsurprising that there was such a widespread apprehension of imminent pain in the arts. To be underfunded was one thing; to be hugely misrepresented and misunderstood was quite another.

But the situation facing the national arts environment went beyond financial pain, beyond hurt feelings, beyond political indifference.

THE REAL PAIN

Outside London, in the regions, the experience of pain was already actual and many feared it would get worse. These voices needed hearing. The testimonies and warnings of organisers of the nationwide 'What Next?' movement, set up in 2013 to explore common ways of responding to the crisis, were significant. Coming from the regions, often from small, vulnerable arts organisations, they became a chorus of canaries deep in the coal mine warning of the threat to their oxygen. 'These are unprecedented funding cuts,' warned one anonymous leader, 'far outweighing the Thatcher days – and completely beyond any of our worst fears a few years ago.'

'Public funding cuts will continue for some time,' said another regional leader, wishing, like most, to remain protected by the mantle of anonymity: 'We have not seen the full impact of local-authority budget reductions. This is about loss of funds and loss of capability.' Taking this thought further, this leader warned:

> The funding cuts are dismantling the arts infrastructure throughout the country. It feels like an assault from an uncaring, London-centric government made up of individuals who are cushioned from the effects of their policies, first because of where they live and then because of their income.

The immediate impact of reduction in local-authority funding was widely feared but hardly surprising. The danger of cumulative reductions at local and national level had been clear at least three years previously. One regional voice put it calmly but effectively:

The extent of reduction in local-government funding is far more than the reduction in the Arts Council's total income. The way the effects of local-government cuts often hit smaller community-oriented organisations and projects makes them particularly insidious and damaging in terms of local cultural engagement and opportunities – like an unseen, creeping, night-time carbon-monoxide poisoning.

The full extent of the threat to the arts outside London was stated by the Joseph Rowntree Foundation in November 2013. As reductions to local-authority funding deepened, the foundation warned that support for institutions such as libraries and arts and leisure centres might cease altogether by 2015. Faced with such a prospect, one arts leader warned of a 'perfect storm of cuts and closures' in the regions in that year. In using such an image, she was not indulging in scaremongering.

More universally, arts leaders in the regions pointed out that philan-thropic giving was not – despite ministerial assertions and urging – an easy way out for them. Most of the giving occurs in the London region and most goes into the major national companies. As one observed: 'There's a great danger of an awful lot of effort and energy being poured into raising very little given the low skill base, little capacity and relatively few prospects.'

A more general experience too was the inability of local authorities to cooperate constructively or institutionally with their own cultural organisations just at the time when calls for partnership were louder, more insistent and more necessary than ever before. Some local authorities failed to consult even their own arts organisations before withdrawing their funding.

Also under threat were local-authority-owned or -funded buildings, the venues where so much arts work takes place. Costing what they did, they appeared a tempting, sizeable and easy cut for a strapped local authority. One regional leader was vocal on this danger:

> The contribution that venues make to a vibrant, sustainable arts world is sometimes overlooked. Artists and performers need

their work to be on a wider stage, they need places where they can come together and without venues this is more difficult to make happen. That wider stage is vital if the arts are to evolve and grow. Small projects, arts organisations, individual artists cannot do this in any substantial way.

As a reminder of the interconnections throughout the arts, the practical and creative interdependencies, this cannot be bettered.

This detailed and closely argued mosaic of how arts in the regions will be damaged by cuts has seldom been presented before or in this way. It warns of institutional failure by local government, as well as the direct effect of financial reductions.

Are there ways of mitigating this pain in the arts, whose full profile and full extent will continue to emerge in the months ahead?

COOPERATE OR ELSE

The importance and the scale of the dilemma was sharply put by one regional leader: 'Will the basic instinct to survive overpower the desire to take risks, show empathy and make room for the next generation?' The faintest glimmer of an opportunity was additionally defined as: 'Finding ways of doing more with less, particularly by collaborating more deeply.' This would be hard to do 'as it will force material change and challenge organisational sovereignty'. In short and put bluntly: 'Will the cultural sector choose to come together in a place to look at how to operate more effectively and sustainably or wait to compete with each other for shrinking grant funding?' That challenge was, interestingly, both defensive and positive: defensive in that it was posed as a way of mitigating immediate financial disaster in the shape of 'Cooperate or else!'; positive in that it invited fresh responses, new types of cooperation among the arts in the form of new opportunities, a way of creating something out of the possible ruins of the old forms and systems.

Yet the possibility of partnership and cooperation must go beyond mere responses to emergency and should extend beyond the arts world

and towards higher education and the voluntary sector. As things stand, such forms of cooperation exist either not at all or in words only. The practical business of defining common interests, shared principles and agreed practices has hardly started. Yet if sectors such as the arts, the creative industries, universities and charities cannot forge new forms of organisation, new types of institution, which command an assured place in the economy, society and the political dialogue, then they will undoubtedly suffer on their own.

The strength of the case for a new alliance between universities and the arts was well made by the director of the Clore Leadership Programme, Sue Hoyle, to the Higher Education Funding Council for England (HEFCE) conference in April 2013. The arts are good partners, she advised her audience of senior academics: 'We are social change-makers; creators of international trust; job-generators; economic boosters; exemplary leaders in straitened times; imaginative; innovative and cross-disciplinary. We engage the public and help create a sense of civic identity.' Hoyle ended with an invitation to arts and higher-education institutions to face the opportunity of cooperation and participation in the interest of both sectors.

Now that the new chair of Arts Council England, Sir Peter Bazalgette, has called for a 'grand partnership' between the arts, local authorities, businesses and higher education, the question should not be: 'Can it work?' but rather: 'When and how will it take place?' It can no longer be an interesting possibility; cooperation and partnership should become an absolute priority.

The microscopic experiences of particular pains in the arts will never be eased by themselves, on a one-by-one, case-by-case, or suffering-by-suffering basis. Fragmented in their responses they will only be myriad foci of misery, disappointment, resentment and regret. A bigger, strategic picture of larger opportunities, newer thinking and braver actions can be the only way to ease the current, intense and growing pain in the arts. And it will only come from the best, most creative leadership.

2

SURVIVING THE DOWNTURN

'It is so much worse if decisions are not made.'
Clore Fellow

*'Passion, conviction, ideas – these are more
important than appearances.'*
Clore Fellow

The arts world in Britain is battening down the hatches against the coming economic storm. While it began to be felt from early 2013, its harshest impact will come in the middle of the decade, when the full effects of the public-spending reductions already announced come into play. Only a fool could be complacent; there are few fools in the arts world. But what can be done when the storm erupts? As Michael Foot once urged the Labour Party conference two decades ago, invoking Joseph Conrad: 'You face the storm, you face it!' How can the arts world follow that advice? In modern management terms it is called 'crisis management'. The wise old saw advises 'never let a good crisis go to waste'. The language of 'challenge' and 'opportunity' is blandly evasive and grossly overused, but at a time of financial cuts and austerity it should be addressed seriously. Doing so involves the highest kind of common sense and practicality. It is the ultimate test of good leadership.

If, too, we expect and hope that government and society will recognise and acknowledge a continuing need – a special need, perhaps – for the arts in a time of recession, there is a prior and more important issue

to settle first: what does the arts world need to do itself to harness and deserve that support in a recession? Exceptional support, even continuing support, must be earned, not assumed.

Underlying much of this discussion is the assumption that the arrival and existence of an economic recession makes the position of the arts in society somehow 'different'. In truth it does nothing of the sort, or should do nothing of the sort. The arts during a recession are exactly the same as they are in boom time or in a period of dull normality. The activity of creation is the same – though the nature of the works created will vary; the pleasure of attendance and experience is the same – if occasionally sharpened by a greater sense of need; the felt value of the arts in the bad times – however the arts are defined, and definitions can be hugely broad – is no less than in the good times; the purpose of the arts – the presentation, revelation and understanding of the exceptional in human experience – remains the same.

In practice, the most important question to be faced in a recession is: 'How do the arts themselves respond?' Every organisation needs a range of strategic and tactical responses to put into operation as needs demand and opportunities arise. In shorthand, they add up to a series of 'dos and don'ts' to use as the storm gathers before it bursts. Such actions are even more essential once the case for funding the arts or not cutting them has been made, and regardless of the outcome. They are more than emergency responses; in truth they amount to an approach to arts management that accepts responsibility in good times and in bad.

TO DO AND/OR NOT TO DO?

First, some 'don'ts', actions to avoid when recession bites, funding is cut and budgets are under pressure.

Don't moan. Unlike the politicians and bankers, we really are all in it together: the arts world, our audiences, our artists, the entire economy. No one will be impressed by hard-luck stories – every sector of society can tell them. Many will be worse than anything the arts are likely to experience. So do not expect sympathy. Hard-luck stories are ten-a-penny.

Moaning sounds like self-pity. 'Not moaning' is different from making the case and arguing passionately for funding.

When cuts are made in arts activity, don't 'shroud-wave' – that is to say, exaggerate the effect of cuts in the arts on our way of life, on society, on the future of civilisation, on the whole world of culture. It is not true as stated, it won't be believed and it won't work. Funding cuts will indeed damage the arts, there will be a loss for those who work in them and those who enjoy them, but nothing is gained by overstating either the scale or the impact of the cuts. Don't exaggerate, but do explain: the evidence of the impact is already there for all to see. Whitehall recognises a 'waving shroud' when it sees one and has long been inured to the shedding of tears. Cries that funding cuts will lead to 'the end of the artistic world as we know it' always fall on deaf ears.

Don't cut the education and learning budget. It is extraordinary how often this is the first cargo to be jettisoned in the budget storm. If education is treated as expendable in a time of crisis, all the earlier commitments to educating the next generation, to reaching out to the new, are exposed as shallow and opportunistic. Either education is part of an arts organisation's core purpose – which everyone insists it is during the good times – or it is merely a convenient piece of window dressing to be abandoned at the first draught of austerity. It may look like an easy budget cut, but long-term credibility is blown if it is treated as such. Cutting spending on education is exactly the same as eating the seed corn.

Don't radically alter the programming in the – vain – hope that a few cheap, popular shows or events will solve the problem – they won't. Audiences will spot what the organisation is up to and it will have sold its soul in the process. It is far more expensive to buy it back in the future. Some artistic risk will have to be modified, but that involves a different set of calculations.

Don't slash ticket prices – those who really can't afford to come because of hard times will not be coaxed in by a few price reductions. It is usually the better off who are smart enough to grab cheap offers first. And why hit precious income streams just at a time when they are needed

most? Value in the arts is appreciated more than mere cheapness, even in times of hardship.

Don't cut internal budgets across the board, 'salami slicing' from every department. It may be presented as 'macho management', which makes the hard and unpopular choices. But it is not intelligent and does not make distinctions about priorities. It is also inefficient, indiscriminate and ultimately ineffective. 'Equal misery all round' is lazy management which dodges the issues.

Don't cut the regular capital-maintenance programmes. It will only come back to bite you when the roofs start to leak, the loos smell, the seats are shabby, the walls grubby, the floors littered, the bins filled with uncollected rubbish. Shabby gentility used to be the acceptable uniform of the English middle classes. It can't be the public face of a supposedly self-respecting arts venue. Be shabby at home if that is what you like, but it is not pretty to look at on a night out.

But do take a very hard look at the capital programme as such if there is one or one is being planned – is it really necessary to start a new-build project at this time? Can it not be put off for two or three years? How hard will it be to raise the funding at a time of financial crisis? Supposing, too, you receive a gift of £50,000. Is it not better used for programming and activity now rather than saved in a capital account for a future dream?

It may sound odd to devise a strategy for surviving a crisis by ruling out the most obvious methods of doing so. But taking the wrong decisions in hard times is an easy and dangerous trap to fall into. Yet warning against facile cuts and decisions, protecting essential activities, listing the actions that should not be taken, does not answer the hard question: where will savings be made when they have to be made, as they certainly do? How to address the task of reducing budgets is crucial, and if well done far more likely to lead to correct solutions and produce better results. Don't begin by cutting the wrong things for the wrong reasons.

For while there always will be budgets to be cut, there is also money to be earned, money to be saved. Having put to one side the management 'don'ts', turn to the far more valuable and rewarding management 'dos'. They must involve income – generating it, conserving it and looking

after it. Some may look tiny; some may be tiny. In a huge crisis, tiny must be taken.

Do make sure you get the maximum take-up from Gift Aid – very few organisations can point to a 100 per cent response rate. All too many don't bother to do so. Yet this is easy money. It also demonstrates an approach to self-help that stakeholders and governments will like. Maximising the take-up from Gift Aid, however small, undermines the Treasury argument that even when arts organisations are offered tax concessions they are too lazy or incompetent to make use of them.

Do make sure the website has a voluntary box for 'suggested additional donation' over and above the ticket price itself. The size of the response is often gratifying and reinforcing; you will learn from it. It is an excellent way of building supporter loyalty. Audiences enjoy showing how much they value what the institution does and offers.

Do review ticket pricing and push it upwards if possible, not stupidly but as and when you can. Historically most arts organisations underprice their work. Cheap seats do not represent an artistic policy. Many members of the audience can and will pay more. While it may seem odd even to think of increasing prices in a recession, consider what low ticket prices truly cost the organisation. Do those who underprice their tickets also undervalue their artistic offer?

Do operate a dynamic pricing policy – called 'yield management' or 'airline pricing'. Here prices are increased as actual demand increases. It is a common and expensive mistake to assume you are doing good to society by underpricing across the board; setting prices low is not an access or outreach policy or even a real community policy. Beyond this, a shift in attitude and approach is needed. Most arts organisations are temperamentally and institutionally inclined to cut costs rather than to drive income. Earning income should be driven in parallel with shaving costs.

Commercial earnings – from bars, hospitality, conferences, car parking, and so on – are likely to be hit first and worst in the downturn. Make sure these budget lines are realistic: too many arts organisations use the 'commercial income' line as an illusory way of budget-balancing. Starting with a realistic base, try not to let recession drag down the whole

budget and business plan. Try asking the stakeholder or principal funder to ring-fence the commercial side of the budget for a temporary period; agree on a phased repayment of whatever commercial debt accumulates during the recession once it eases. It means that some of this debt may have to be carried for three to four years on your behalf, but it should not be a huge sum to the stakeholder and it would mean that an inevitable immediate commercial shortfall would not jeopardise the continuity of arts programming. (This approach was successfully adopted at the Barbican in the previous recession thanks to the cooperation of the principal funders, the City of London Corporation.)

Suggest to the stakeholder or funder that any inevitable reduction in direct funding for arts programming – whatever the sum turns out to be – should be tapered or spread. If you have single-year funding, spread the cuts over three years; if three-year funding, smooth the cuts over five rather than three years. Backload the cuts to the end of the funding period rather than the start. Again, someone has to carry a quantity of increased debt, but interest rates are low for years ahead, and if spreading cuts over a longer term were agreed it would be a small price for the funder to pay for diminishing the impact that immediate cuts would have on the arts programming.

All these suggestions depend on a friendly, wise, preferably enlightened stakeholder. Of course, if he or she is narrowly and crudely driven by the perceived imperatives of budget-balancing, these suggestions will not be welcome. But there is no gain if the question is never put. Silence and a mute, passive, probably resentful acceptance of funding reductions is the worst option. Assume, at least, that there is a shared community of interest between the organisation and the stakeholder; assume a shared interest in ameliorating the effect of whatever cuts loom. Nothing is lost by optimism.

But the most important aspect of the response to funding cuts is to look very hard at the organisation: at its own costs, at the way it is run and organised. It is hard to believe that there is an arts organisation – even a single one – that is perfectly, economically organised. Every arts organisation has its own hidden, unacknowledged agenda consisting of

a programme of restructuring and reform that should be carried out but for which the determination to act is lacking. 'Oh Lord, make me more efficient but not just yet!' A funding crisis offers the compelling justification for that restructuring programme that should take place but has been avoided in the past. The time for need has arrived. It should be implemented properly and systematically. Intelligent, honest restructuring delivers changes that are targeted, selective and prioritised, the reverse of the lazy, 'cut them all a bit' approach that almost always characterises emergency across-the-board funding cuts.

Reform in a time of recession, too, offers the prospect of emerging from recession better organised, more efficient, more able to develop and advance than before the recession struck. The experience of all businesses is that those who tackle weaknesses in internal structure early in a recession emerge faster, fitter and better than those who do not.

And *do* be clever. The arts are about ideas, thoughts, innovation, originality, a bit of madness, the unexpected. Even if the venue can't be filled with substantial events, turn it into a place for ideas, debates, provocation, discussions, human and social engagement. Everyone wants to talk, to have their say, to speak on the scores of subjects waiting to be debated. The venue can always be a platform for intellectual, imaginative and creative exchange. It is a space for use, for public involvement, for curiosity. Make it stay alive by using it, staying open, obviously available. Don't let it go dark, fall silent, look and feel defeated. That would be unforgivable and is unnecessary. This agenda is simple: 'E.T.D.' – 'enjoy, talk, do'. All audiences like opportunities for doing all three.

Such an agenda also gives the organisation the opportunity to engage with the community in such a way that its own legitimacy is increased. The comparatively recent notion of 'legitimacy' in an arts context can yield valuable dividends. It reminds us that support within and from the community goes far beyond attendance and buying tickets. Deep-rooted community connections confer legitimacy, which allows supporters to 'engage', 'defend' and 'stand up' for their organisation. Any organisation which 'opens its doors' in the widest sense, physically, artistically and intellectually, is well on the way to earning its legitimacy.

Do take a hard look at partnership and cooperation with other institutions. This could well be the agenda of the future, one never seriously undertaken because the real need has not existed. It starts with partnership – or outsourcing – over back-office functions such as finance, premises, hospitality, activities that must be done efficiently but do not truly define the organisation's character and personality. Partnership can then move into cooperation over a common approach to education and outreach, to marketing, to the use of social media, even to the programming.

At the highest strategic level, the time is ripe for major initiatives of cooperation between the performing and visual arts and higher education. The absence – barring a few exceptions – of such cooperation represents a glaring omission in the past and a rich and yet to be fully defined opportunity for the future. If the years of funding austerity were to yield a new era of connection between universities and the arts, what a reward that would represent.

This may sound like a difficult and challenging programme of action. Even if not all of it were put into effect – and it is worth making the effort to do so – it would mitigate the impact of funding cuts. It is very unlikely to solve them all. But doing what is needed, what can be done, what must be done, allows the possibility of something else: to make an appropriate case in public about the effect of whatever cuts are imposed.

MAKING THE CASE FOR THE ARTS

For a start, the principal funder and backer, the stakeholder, will not be able to accuse the organisation of inaction, indifference or general budgetary wetness. There will be a ready answer to any question like: 'Why aren't you doing such and such?' It would be: 'We're doing that already!' In return the arts are entitled to ask politicians in particular: 'Why are you cutting such and such?' And on the foundation of robust and determined actions, the arts can and should question and debate as robustly as might prove to be effective.

There are certain key realities in public life. If the arts don't stand up for the arts, no one else will. Do not believe civil servants and politicians who

urge you to negotiate things quietly, backstage, behind the scenes – that is the Whitehall way. It is usually a trap. Civil servants and politicians love a quiet life; getting you to gag yourself is the first and oldest trick in the book. The main reason that arts funding became reasonable in the third year of New Labour was that the arts made a huge fuss in the first two. Ministers later admitted how effective – and how helpful – the cries from the so-called and much disparaged 'arts luvvies' were at the time. Much of it came from the publicly reviled Shadow Arts Council in 1999–2000, led by Sir Peter Hall, Norman Rosenthal of the Royal Academy and myself. It was unpopular with ministers and highly inconvenient, but prodded Tony Blair's Downing Street to address the question of arts underfunding (see my earlier book, *Art Matters*, Chapters 6 and 7). Remember, too, that though protests and leaks may be the last refuge of the weak, they are also the first refuge of the strong. Especially when those campaigning robustly have put their own house in order financially, artistically and organisationally.

There is a deeper reality in the realm of public finances. Cutting single-figure millions – or double-figure millions – savages the arts but has no – absolutely no – effect on the overall national deficit burden. By 2014, that deficit will have risen to £160 billion. If socialism is the language of priorities, then priorities are – or should be – the criteria of cuts. The wise politician would say that arts cuts which damage the decade of wise investment from 1999 to 2010, which damage the regions far more than they damage the south-east, which harm the small more than the large, which cut the taproots of national creativity but contribute nothing to solving national indebtedness, are poor social policy.

The arts must stop being apologetic about what was achieved in the period preceding the financial crisis. The extra funding was well used in providing the highest level of artistic quality and excellence across the spectrum: arts organisations are well and efficiently led, managed and run; attendances are high and remain so in the recession; and institutions connect to their local, national and international communities as never before.

During the decade in question, the arts not only set and maintained the highest standards of excellence and quality in what they created.

They also absorbed the social outreach and education agenda into their system, their outlook and their values. When museums and galleries were made free in 2001, attendances soared; when more funds were provided for theatre, more tickets were bought. The arts work, they do their job for society, community and people. They are a success by any national or international criteria. Why cut them? If those who work in the arts do not ask that question, no one else will. The question can be put with confidence on the basis of actions taken and risks avoided, all of which demonstrate responsibility, professionalism and self-help.

The arts are valued, used, desired, appreciated and understood by millions. Standing up for them is not a selfish, private, self-regarding, self-indulgent act. It is an act of the highest degree of social value. Staying shtum is not an option, it is an abrogation of responsibility. But the rhetoric can only follow the hard actions taken to mitigate the impact of cuts in the arts in the downturn.

3

LOOKING FACTS IN THE FACE: THE CASE FOR THE ARTS

*'I know what the arts do – they are about place,
about sense, they belong to the people.'*
Clore Fellow

*'The arts humanise people – they take risks,
they work beyond parameters.'*
Clore Fellow

There is a Whitehall game, an essential civil-service gambit deployed at the very start of budget negotiations over future funding for the arts. It goes like this: 'Why should the government support the arts at all? Prove that they have an effect on the economy. Show that they are useful to society. It is, after all, taxpayers' money. MPs need proof to show their constituents. Ministers don't like arts funding much either. They must claim to love football and pop music; they are embarrassed to talk of the opera. Whitehall and Westminster need the evidence – after all, everyone insists on "evidence-based" policy making. Join the club!' And while the politicians and civil servants are about it, they throw in a bit of name-calling: 'Try to stop acting like luvvies! And cut out the whingeing!' In the conventions of the funding game, accusations of whingeing – publicly complaining – and 'acting like luvvies' – self-indulgent theatricals – are cheap hits but can be hits nevertheless.

Some such battery has been part of every major political negotiation over arts funding for at least a generation. It is presented as a direct challenge, an unapologetic confrontation which carries the implication – even bureaucratic expectation – that the questions raised are unanswerable. The name-calling is significant too, and a key part of the game. It should be resisted.

In reality, the arts singly and collectively have been providing answers, good answers, statistical answers, to these questions for most of the past generation. Gone are the days when defenders and supporters of the arts took refuge in attractive, high-minded but unverifiable assertions about the absolute worth of the activity. Such claims about intrinsic value have their place and are by no means without meaning, but they have long ceased to be influential or persuasive in the rough and tumble of political funding skirmishes. Artists and audiences will always recognise and value the grand abstractions often used to explain the complex and inexplicable experiences of the arts. They are an essential part of private understanding of the arts and public dialogue about them. Yet the noisy, often ruthless public dialogue about arts funding must be conducted in a more robust, practical, matter-of-fact way.

For there are hard answers, economic answers, factual answers to questions about the value of the arts. Measurable and measured indicators demonstrate impact and value beyond question. Since they exist, why have they been so often ignored?

MEASURING VALUE

Arts funding at any level is often challenged – directly or implicitly – as if it is an intolerable and unacceptable burden on an overstrained national budget: some £400 million a year in grant-in-aid. The reality could not be more different. Total government expenditure on the arts in Britain is less than 0.5 per cent of the national budget. This represents a charge on the taxpayer of just 23p per week or 3p per day. It is or ought to be impossible except in crude political debating terms to think of such spending as any sort of burden, let alone an unacceptable one. Such expenditure

is affordable; it should be afforded. Significantly, the numbers themselves are not in dispute.

So the Whitehall argument performs a sideways shimmy, altering its line of attack: 'Of course, the numbers may not seem large in absolute terms, but at a time of national crusade against the deficit, every few hundred million counts. The arts can't be left out of general hardship. We're all in it together, after all!' There are two replies to this. The first is that even if all £400 million of government support for the arts were abolished altogether, the effective impact on the national deficit would not be noticeable. It would not register in any financial calculation except on the right-hand side of the decimal point. Such sums are 'lost in the roundings' – Treasury speak for numbers so small in the totality of the national budget that they get 'rounded up' to the next billion.

The second answer is that any such cuts, far from helping the economy, would damage it still further. The arts are not some private, personally focussed activity, of no concern except to those who are interested in them. They amount to a significant sector of the economy; they are a major employer. Some 700,000 people work in the arts. Reducing, let alone abolishing, arts funding creates unemployment, increases the numbers on welfare and benefits, lowers national tax receipts, is economically counterproductive and weakens local economies.

And further damage is felt in other sectors of society. Research has long established that the arts have a beneficial effect on health and well-being, educational achievement, social cohesion and even crime prevention. Just because these effects may not have been conclusively measured does not mean they do not exist. (It is generally agreed that they do.) Cuts in the arts do not affect only the arts; they do damage elsewhere in society. Such cuts carry a further cost elsewhere rather than representing a saving.

Too often spending on the arts – whether at local or national level – is presented, treated and regarded as a net cost to the exchequer and to society. In fact it is a net and very substantial benefit. Every £1 spent by local authorities on the arts levers a further £3.83 in additional funding. Every £1 invested locally generates £6 of economic activity. One of the most substantial pieces of research concluded that within the 'square

mile' of the City of London, arts and cultural organisations added £225 million to the City's net value and sustained 6,700 full-time jobs. The Local Government Association assessed the economic value to their local-authority members of music and the visual and performing arts as £4 billion a year.

The arts are not merely a personal 'reason for living', essential as that is in any discussion of the arts. Companies and businesses know how to value their presence and existence. According to the consultants McKinsey, the hardest-nosed of the hard-nosed, companies seeking to relocate their enterprises place the cultural and social environment of any proposed destination as the key factor in their decision making – a factor ranked higher even than housing, transport or schools. Recently, a major employer in a northern city felt obliged to warn the local authority that it wished to expand its workforce. However, the skilled technicians and managers that it sought would not move to a city that lacked a lively arts and culture infrastructure. Put bluntly, cultural infrastructure was valued more highly even than internet connectivity or road and rail connections; it engages the human intersections of thought, ideas and enjoyment that arts and culture represent.

At national level, the positive economic impact of the arts looks even larger. If £213 million of Lottery players' money is added to the government's basic grant-in-aid of £400 million, this total of £613 million of support for the arts yielded no less than £26 billion in gross value from the arts and cultural industries. This is, or ought to be seen as, a conclusively huge multiplier effect, a 'return on investment' provided by few other areas of government spending.

And the funded or subsidised arts connect to activities all around them; they do not exist in isolation, in some detached, hermetic sphere, remote from the needs and priorities of everyday life. They connect with the vast and growing sector of the creative industries. According to an authoritative report by the National Endowment for Science, Technology and the Arts (Nesta) published in April 2013, the creative economy employs 2.5 million people and accounts for no less than 9.7 per cent of the UK's gross value added. The report confirms throughout that

the connection between the arts, the world of culture and the creative economy is deep, integral and essential. To disrupt these links – even to diminish them – would be ignorant conceptually and damaging practically; it would undermine, not reinforce.

The subsidised arts connect with the commercial sectors in intimate, practical and functional ways. They are one sector joined at hip and heart. A recent Arts Council study found that 87 per cent of those working in commercial theatre learned their craft in the subsidised theatre at some stage; 70 per cent of these felt that it had been vital to their career development. The brilliant, internationally lauded Olympic opening and closing ceremonies in the summer of 2012 were created by Danny Boyle and Stephen Daldry. Both were originally products of state-supported theatres in Sheffield who then moved through Hollywood cinema to international eminence. Their examples are only two demonstrating the rich creative integration in Britain of the commercial and the subsidised elements in theatre. And every sector of the creative industries, from graphic design, to advertising, to games design, finds a similar integration between the publicly funded and the privately exploited.

Above all, the arts connect with people – being involved in the arts is far from a minority interest and activity. Almost 80 per cent of adults in England reported that they 'engaged with the arts' in 2012. A more concrete number from the same year recorded that almost 90 million attended Arts Council England's largest institutions – museums, galleries and theatres – defined as those that the council funds on a regular basis.

Such contact with individuals goes further, deep into the world of private giving and philanthropy. No less than 12 per cent of national arts budgets is provided by philanthropic giving. This ranges from the large foundations such as the Sainsbury Family Charitable Trusts and the Garfield Weston, Esmée Fairbairn and Paul Hamlyn foundations to a growing number of smaller private donors. Tax concessions make it easier to give, but the sum of cash contributed from tax-paid income still represents a large social contribution. This should be recognised and treasured. Giving connects the arts with individuals who support

them as a way of enriching a local community or supporting a valued national institution. Philanthropy and altruism are a crucial part of social cohesion.

The evidence for the value of the arts is in this sense negative. If the arts failed to attract philanthropic altruism, if individuals did not think support was worth giving, it might throw a poor light on their fundamental social value. But they do attract such support and it emphasises the value of and values attached to the arts. David Cameron's 'Big Society' concept may be as politically dead as the dodo, but private philanthropy suggests part of it may be alive.

If there were a credible national 'happiness index', one that attempted to probe the contribution that the non-material plays in human satisfaction, the presence, existence and availability of arts activity would account for a significant proportion of that index. A YouGov poll after the Olympic opening ceremony found that 68 per cent of those who watched 'felt proud to be British'. An IPSOS Mori survey found that after the royal family and the NHS, 'culture and arts' scored most highly (24 per cent) among British people in the things they were most proud of. (Combining as it did the royal family, the NHS and culture and the arts, no wonder that the opening ceremony of the Olympics struck the intense popular chord that it did.)

Perhaps a 'feel-good' index amounts only to the softest of soft indicators. That does not mean it is neither real, strongly felt nor ultimately worthwhile. It is not only numbers that count – so do feelings. But how can they be measured? As the saying goes: 'Measures measure what measures measure.'

The world outside watched the Olympics and drew positive conclusions about the country. Britain's arts projected themselves on an international screen, testifying to a national capacity for originality, innovation, creativity, vigour, wit and fun. Such are attractive qualities, expressions of so-called 'soft power', an increasingly valuable and valued arm of international diplomacy, especially in a world where so many formal British diplomatic or military initiatives are questioned, regarded with suspicion or deeply unpopular internationally.

Here is where the mystery starts, the political puzzle begins. The hard evidence exists for the effectiveness of public subsidy of the arts. The numbers are there; the audiences attend; local economies flourish. Sustained or credible questioning of public funding for the arts at any level should be unconvincing. Yet it continues at each public-expenditure round with varying or increased intensity. It continues without regard to the evidence regularly presented that the arts contribute rather than cost, that they deliver widespread benefits to very wide communities. They are inclusive rather than divisive, democratic rather than elitist, dynamic rather than static. Why does the world of politics spend time disputing the smallest part of the national budget?

PUTTING THE EVIDENCE ACROSS

Suppose that those who generally represent or speak up for the arts are – as it is sometimes suggested – the whole or at least part of the problem. That the case they make for arts subsidy is essentially for the subsidisation of pleasant activities most valued by a tiny minority and which that tiny minority can certainly afford to pay for. Suppose that all the claims for the intrinsic value of the arts are overblown and used as a convenient cover for private pleasure. Suppose that the great public arts organisations and institutions are indeed more interested in keeping the 'wrong' people out than they are in attracting the 'right' people in. Suppose that the worst case that could be made against the 'elitist' and exclusive atmosphere and practices of the arts world were accurate. Would that account for the nature and terms of the public and political debate?

Even if it were judged to do so, it could only do so by ignoring the hard, clearly established and increasingly researched numbers that paint a wholly different picture of the arts and make a different case for their subsidised existence. When in April 2013 the Secretary of State for Culture, Media and Sport, Maria Miller, called for the arts to help her 'make the case' on economic grounds – with the strong implication that the case had not been made, was not being examined and probably could not be made – she could not have known that, within weeks,

two reports – from Arts Council England and Nesta – would deliver comprehensive evidence of the large contributions to the economy made by the arts, culture and the creative sector. Using a slightly different approach from the Nesta report, the May 2013 report for Arts Council England by the Centre for Economics and Business Research (CEBR) concluded that 'businesses in the UK arts and culture industry' generated aggregate turnover of £12.4 billion and gross value added of £5.9 billion. Surely such figures should change the Treasury's mind, provided that they are used and presented.

In the light of such hard, available and immediate evidence, the question returns in a slightly different but even more intense context. Why is the increasingly indisputable economic and social evidence for the value of the arts ignored in the political debate? There could be several explanations.

In part it recalls the 'nuclear power station' syndrome. Question: 'Why did the investment committee authorise a multi-billion-pound spend on a nuclear power station in ten minutes but devote half an hour to the location of the bicycle shed?' Answer: 'Because they knew something about a bicycle shed!' So: 'Why do MPs and ministers devote so much time to the least significant budget item – spending on the arts? Because they (think) they know something about it but know much less about far more substantial budget items.'

In part, it reflects understandable human behaviour. Challenging spending on the arts is a displacement activity, far easier than engaging more demanding policy matters. It often amounts to no more than name-calling and low-level abuse. It is time that the arts community rejected the lazy and intentionally pejorative collective noun of 'luvvies' so habitually deployed against them. Those in the arts are usually less well paid and harder working than their detractors.

In part the line of least resistance proves irresistible. The practice of 'equal misery' all round is the least and laziest way of reducing spending practised by governments, companies and public organisations. It involves turning your back, closing your mind and shutting your eyes to facts and evidence. Of course government policies proclaim that they

are 'evidence-based'. This only applies when the evidence points in a convenient direction and minds have not already been made up. The evidence for the economic value of the arts now exists. But government spending should also reflect priorities and make choices.

Besides, there are few popular headlines to be got from supporting the arts — fewer votes, too. The populist vocabulary of 'self-indulgent luvvies' habitually deployed by politicians and press when convenient still has time and space to run. There are said to be no votes in challenging it. Yet surveys show that even families that are light users of the arts strongly want their children to be involved in them. It is time to put glib assumptions about general voter indifference to the test.

Does something more fundamental lie beneath the deep questioning of the arts? Is it because those who undervalue and diminish them are... No, I won't say it. I won't say 'philistines', which is name-calling and unworthy of a serious, reasoned argument. The 'p' word — 'philistines' — the 'e' word — 'elitist' — and the 'l' word — 'luvvies' — should be banned from use in any serious discussion. There must be a neutral word to describe those who habitually undervalue and diminish the arts. I have never heard it. Such people do exist.

But even if it were true that there were no easy votes in speaking up for arts support, it might also be true that there were even fewer votes in calling for the arts to be cut and reduced.

Yet such attitudes represent a large wall of institutional opposition or inertia towards defending the arts, still less towards funding them so that they flourish. The message for the arts is curiously simple. Defence lies in our hands, those who make, those who pay, those who attend. The facts exist; they are there to be used; they should be used again and again and again; they should amount to a battering ram of fact. Are they killer facts? Possibly, but only if their use is relentless. They must not be set aside and abandoned.

And in the meantime, the arts world must box clever. To the congenital sceptic, to the ruthless bureaucrat, to the calculating politician, to the class warrior, to the inverted snob, the case for the arts can easily be put in their terms. It goes like this:

'The arts must be funded because they are efficiently run, transparently led, meet their objectives and deliver all the outcomes set. People are healthier, children better educated, communities more harmonious, towns and villages more prosperous when open to and involved in arts activity. National economic activity is boosted, research and innovation are advanced, entrepreneurship is galvanised, philanthropy is stimulated, employment is increased, tax take is grown, social benefits are increased and international reputation and prestige are enhanced as a direct result of public support for the arts.'

If that is still regarded as too vague, it is possible to use the critics' own language, the language of bureaucracy and managerialism: 'Arts investment is a high-yielding, multifactorial multiplier delivering diverse and complex social, economic and psychological outcomes of an unpredictable, at times unquantifiable, but always ultimately verifiable nature. While certain outcomes are more subject to precise metrical validation, most can yield results that are beyond the merely subjective. But "going forward", the "direction of travel" is clear. Investing in the arts is money well directed. It represents some of the most productive investment open to government or local authorities. Investing in the arts amounts to taking the "easy wins", to "picking the low-lying fruit". Not to take them would be self-defeating and masochistic, to allow the funders to succumb to prejudice rather than accept reasoned evidence.'

One can take one's pick of the language to use. Both reach the same conclusion. In very plain language: the arts yield more than they cost; they are a benefit, not a drain. It needs saying again and again and again. Truth often does not prevail. Reality always does.

In the end, the arts must return to their own language, their own thoughts, based on direct experience and evidence of the myriad human transactions that take place daily. The arts are like research and innovation – without them ideas and society would stagnate. They are not the principal agents of change, but they are part of it. The arts play their part in national health, well-being and contentment. As one former Clore Fellow put it: 'The arts give so much – they get so little – they

use so little – give them the benefit of the doubt.' It should be possible. The facts are on our side.

Because the case for public investment in the arts is also extremely broad-based, it deserves reiterating in its whole.

Government direct spending on the arts through grant-in-aid runs at £400 million. This is 23p per taxpayer per week, or just 3p per day. This can hardly be represented as a burden.

Taking direct grant-in-aid (£400 million) and lottery funding together (£213 million), this direct investment of £613 million yields gross value from the cultural and creative industries of £26 billion.

Cutting spending on the arts contributes nothing to solving the national deficit. Since the arts employ 700,000 people, cutting expenditure only creates unemployment.

The arts contribute more than they cost. Every £1 spent by a local authority generates £6 of economic activity.

Companies looking to relocate value good arts and cultural provision more highly than housing, schools or transport links.

The commercial arts are directly and intimately linked with the subsidised sector. Seventy per cent of theatre workers state that their time in the subsidised theatre was a key part of their learning. *War Horse* started at the Royal National Theatre.

And connections are vital. The arts connect with people: 80 per cent of English adults 'engaged with the arts' in 2012. The arts connect with philanthropists who make much art possible: 12 per cent of national arts budgets come from private giving. The arts connect with personal content-ment and satisfaction: as measured through a national 'happiness index'.

And finally, the arts connect with the outside world: as a vital ingredi-ent in Britain's projection of 'soft power', a power that influences when 'hard power' is ineffective.

4

THE DOS AND DON'TS OF RUNNING THE ARTS

*'The states of leadership include reluctance,
fear, bravery and more bravery.'*

Clore Fellow

*'Leadership is like cooking, the right mix, bit of a stir,
experimentation; eat your own food, take responsibility.'*

Clore Fellow

Often it is the provocative thought that stirs the mind. A prominent colleague in the arts put one squarely in front of me. 'How does one keep one's inner amateur alive and alert,' he challenged, 'as we confront the professionalisation of our role in the context of a rampant international culture of managerialism?' The message was clear, the dilemma acute, the need for an answer pressing.

His challenge placed an almost universal question in the arts as bluntly as it deserved to be put. It was very broad; it contained three parts; it could not be ducked. First, how can one survive as a fresh, alert, responsive person, an amateur in spirit, a human being not an automaton, allowing oneself to do one's job with pleasure? Second, how far has the role of arts leader, or arts administrator, been professionalised into that of cultural manager, and is that a good or a bad thing? Third, are the culture and the values of the modern cultural manager so weighted and bullied by managerial cant and slogans that the arts themselves are

sidelined, neglected, overlooked or ignored? Have the true roles of arts
leader and arts manager – and they have distinct roles – been elbowed
aside, crowded out, marginalised under this pressure from the novel and
probably intrusive notion of 'cultural management'?

They can be answered most usefully by studying the intersections
between the arts leader and manager and the way they interact with what
are universally known as 'key stakeholders'. (Like it or not, this is one
managerialist concept that is here to stay.) These relationships involve:

- dealing with governments and stakeholders;
- dealing with audiences;
- dealing with yourself;
- dealing with colleagues;
- dealing with change; and
- dealing with donors.

These are interactions that represent the tidy parts of life, the predict-
able parts, the unavoidable parts, where a degree of thought, system and
organisation offers a decent chance of meeting the challenge. The untidy
parts – in arts leadership as in life in general – are almost as important,
considerably less manageable and therefore require even more attention.
That attention includes an understanding that at some particularly untidy
junctures of life, the best, perhaps the only advice may be very common-
sensical. It may include a warning against precipitate action – 'Don't just
sit there – do nothing' – and a necessary reminder about trying too hard
to demonstrate relevance: 'the importance of being useless'.

WHO CALLS THE SHOTS?

To start with, 'dealing with governments and stakeholders' comes close
to falling into a trap. For the notion of 'stakeholders' is a gold-plated piece
of managerial cant but sometimes a simply unavoidable one. Why start
here? Because it pushes to the very top of the agenda the fundamental
issue of: 'Who's boss around here?' or: 'Who really calls the shots?' or any

other variant of the phrase. If the answer is: 'The government calls the shots,' because the paymaster will also be the key stakeholder, then the game would seem to be up.

Yet the paymaster does not need to be the controlling or directing stakeholder. I will take one example from my direct experience. The Foreign and Commonwealth Office was for 80 years the direct funder of the BBC World Service through the grant-in-aid. This was separate from and additional to funding for the BBC domestic-broadcasting services, whether in television or radio. But the Foreign and Commonwealth Office had no editorial or policy control of the World Service's broadcasts. It might be the principal funder, but it was never the principal stakeholder – that was always the World Service's worldwide audience. They were, literally and metaphorically, the 'owners' of the international broadcasts, the people who needed them most, the people without whom the World Service would have had no reason to exist.

Was this more than sleight of hand to keep editorial, journalistic independence distant from government control? It was certainly an essential and deliberate manoeuvre around a point of principle. The World Service depended on a journalistic commitment to the values of editorial independence and truth-telling. This was a necessary mission. Whitehall, on the other hand, revolved around the delivery of government policy and priorities and the pursuit of the national interest. That was its necessary mission. If the latter were allowed to dominate the former, if national necessity trumped journalistic veracity, the broadcaster's credibility would be lost. The crucial paradox was that the World Service did indeed deliver broad national aims, expressed fundamental national character, but did so only because it was not slavishly following government objectives or political instructions.

Could this subtle shimmy be used to apply to the arts? Assume that this was the only one available and the lesson would emerge. Governments can – and should – fund the arts, though the exact level of the funding varies according to the state of the national exchequer and the inclinations of the government of the day. Whether government support runs generously or miserably, the arts must be left alone to do their job. Governments

shouldn't tell the arts to what purposes to put the money. Why? Because it would distort the arts. It wouldn't work. The so-called 'arm's-length' policy – defined when the Arts Council was first created in Britain in the 1940s and a guiding principle ever since – was a recognition that the best results came when the arts were left to do their professional and creative best, within the framework of practice and values that reflected the world of the arts themselves.

Increasingly, governments and local-authority funders fell in love with 'instrumentalism' during the late 1990s – put shortly, the arts were just another part of the national budget and therefore were no different in what they were expected to do from social, health, educational or economic policy. As a result, governments of all shapes and at all levels found that restricting their interest in the arts that they funded to an 'arm's-length' distance was very difficult and increasingly unattractive. Worse still, the theory of the 'instrumental' role for the arts, the role of social utility, was a plausible and – to some – politically acceptable form of interfering with the arts' claimed freedom to be independently true to their nature. This was a moment of real danger for the arts and their leaders. Had they been boxed into an instrumental corner?

FOUR POSTURES

The arts leader and manager has at least four possible postures to adopt in resisting attempts at such direct pressure. First, the very low posture: to kowtow to authority. 'If that's what the government wants, who are we to dispute it? Besides, doesn't democratic accountability demand that we do?' This is a possible line, one that affords a quiet life, though hardly a dignified one: major institutions have lost their sense of purpose and their value system – ultimately their soul – by bending the knee. This posture confuses the 'stakeholder' with the 'dictator'. Such capitulation will often be the response of the plain cultural manager.

Second, the high-posture tactic: to confront. This demands that the arts leader – for this is classic leader territory – tells the over-assertive stakeholder to 'get lost', albeit politely and rationally. The justification would

be that it is their business to know about, to create, to manage the arts, not the public funder's. This is a possible tactic, it may seem risky, but could be very effective. In truth, politicians and bureaucrats respect such a response even if they would never admit to it; think what a bad example it would set! Those – and they are many – who manage to pull it off find it justifies the risk and effort. For those who try and fail must try another route.

The third, the median posture, is to evade, to duck and dive, to smile and smile and be a liar. Imagine a stakeholder or funder appearing with a particularly intrusive, officious, onerous policy decked out in the trappings of transparency and intended to make the arts do something that they are not primarily designed to do. In this scenario, the arts leader would greet it warmly and effusively. The greeting would be followed by a steady list of practical, occasionally philosophical, objections, warnings and cautions, accompanied always by the deepest encouraging effusions about the intrinsic excellence of the idea. This game must be a long one. If pursued with determination, and played over time, the initiative can be blunted, perhaps buried, always with assurances of the deepest of regrets that such a great idea could not be realised in practice. This is in essence the 'Sir Humphrey defence', turning the classic mandarin gambit back on itself.

The fourth, the most sophisticated, is the two-faced posture: to accept and adapt. Here, the institution warmly welcomes the intrusive government initiative but then turns it into something it wants to do anyway; it is glad the government will fund it, and persuades the government to think it is delivering what they asked for in the first place. It must be a sophisticated and credible player to use this gambit. Some of our major British arts leaders are adept at it, and watching it in play is a bureaucratic delight. It has a high success rate. But it is not for the faint-hearted or naive.

If you don't get this part of life right – dealing with stakeholders – then you're in trouble from the beginning.

AUDIENCES AREN'T STUPID

Part two of the cultural managers' kit: 'dealing with audiences'. Why are they not at the top of the list of groups who matter? They are your real

stakeholders: no audience, no arts centre. Never think that audiences are less intelligent, less curious, less informed than yourself. They aren't. Never patronise them, never sell them short, never seek the lowest common denominator, avoid the middle ground, eschew easy attempts at bribery by cheap offers. Trust them and they will trust you, and may even come to surprise you.

Take this example from the Barbican. When the sole resident theatre company, the Royal Shakespeare Company (RSC), left the Barbican almost 20 years ago, the universal opinion in the London theatre world was that the Barbican was finished as a theatrical venue. It was confidently predicted by the theatre world that no subsidised company would take on the theatre without additional funding, which was neither available nor on offer. No commercial company would use it, except on the poorest of rental conditions and on the very limited occasions that it suited commercially. Theatre consultants could define no kind of theatrical programming that stood a chance of succeeding in such a venue in such a distant part of London's theatre world. What was left? Should the Barbican's superb purpose-built theatre simply 'go dark', another instance of the right venue in the wrong place at the wrong time? Yet hadn't it been specially built for the needs and wishes of the RSC? Weren't the sight lines perfect, the nearness of every member of the audience to the heart of the stage precisely calculated? Yes, yes and yes. But when the company for whom it had been built decided they had had enough, it looked as if the very special nature of the features designed for the RSC's needs made it unsuitable for anybody else.

The Barbican's theatre team, led by the arts director, Graham Sheffield, and later by his successor, Louise Jeffreys, decided that international theatre and multimedia, multi-art-form theatre offered the only way to the future. The programming team established international partnerships with companies and artistes such as Merce Cunningham, Mark Morris, Declan Donnellan, Robert Lepage, Simon McBurney, AfroReggae, and many more. Was there exact market analysis and forecasting behind their decision? No. It was something far more important and valuable, the kind of judgement that only arts leaders and arts professionals could have

taken, judgement based on knowledge of the theatre scene, understanding of the way theatre was evolving, awareness of audience interest and a sheer hunch that new audiences could and would be attracted. It was a risk, the kind of risk that arts professionals must take; but a risk deeply informed by professional knowledge and understanding.

Who turned up to buy the seats for this radically new programming? Not the seemingly loyal RSC audience. Loyal they were, of course, but to the company, not to the place or the building. Overwhelmingly, they voted with their wallets and took their interest and their bottoms elsewhere. They just vamoosed. It was in the end their loss, not the Barbican's, though we could not have predicted that with confidence. In their place, an entirely new audience appeared – younger, more hip, more diverse, more curious, more experimental. Did the Barbican seek them out through highly sophisticated marketing ploys? Not really. The new audience found us because the programming offered what they thought they might want to see – then came to see it. In part this reflected the still-emerging world of personalised communications.

Did the Barbican theatre team set out to change the audience? Not in so many words. It became – as did the entire centre – the most ethnically diverse in London. That was not an artistic aim, not an explicit objective, not a direct policy. Did an external stakeholder set a changed, more diverse audience as an objective? No, no and no again! Had the Barbican set out intentionally to increase the 'BME' – black and minority ethnic – proportion of the audience as a matter of policy it would not have occurred so successfully and could have distorted the programming decisions into the bargain. The decisions were based on what seemed good, exciting and worth seeing. The art came first; the beneficial consequences followed.

This key experience separates the true arts leader from the mere culture manager. The theatre programming had to change because presenting programming you believe in is your most important single artistic act. The audience – though it was not wholly clear where it was coming from in any sense – was trusted. It was not bribed, bullied or cajoled. Audiences came because they in turn trusted the institution, which they could see from the programming believed in itself. Self-belief was catching.

WHAT PRICE METRICS?

In many cases, the policy demand to increase the BME percentage of the audience – or the under 25s, or the lower-income groups, or whatever the policy priority happens to be that month – finds itself expressed in numerical targets. Ah, the metrics, the great God of Numbers. Numbers have their place, but the consequence of driving artistic policy through numerical targets is that the cart of objectives comes before the horse of policy. That is the approach of the cultural manager. To create an artistic policy driven by numbers as a priority inevitably skews the policy itself. The right one will deliver the right numbers. That is the way of the arts leader. It is a huge difference.

Worryingly, so much of the arts world is still required to live by a structure of specific and numerical objectives. Yet the evidence grows that such targets are broken reeds in almost any activity where policy makers rely on them.

At a recent Whitehall meeting between business leaders involved in the arts and a middling government minister, the use of objectives in their respective businesses was the topic of the day. Whitehall wanted to know, needed to know. Business, after all, ran the clearly stated official message, was so much more efficient and effective than the civil service or politicians – or the arts! It was time to learn.

One major business leader observed helpfully that no more than eight objectives should be used to run a major corporation. He added: 'In my experience, if you ever get more than half the staff to sign up to half the objectives, you are doing very well.' At this, the minister seemed to turn pale and wriggle in his seat. After the meeting, the businessman asked one of the senior civil servants why the minister looked discomfited. Civil servant: 'Because we spent the morning drawing up no fewer than 38 objectives for the department!' Such is the result of the uncritical adoption of a slavishly applied objectives culture.

So what should be the artistic leader's response? There truly is only one choice. Resist the imposition of targets that are irrelevant to your artistic purposes. Explain that the metrically defined can only be a guide to action. It

must not become a straitjacket to creativity. The worst and weakest response would be to sit back passively, groan privately, but then adopt someone else's hard objectives as the driver of your arts policies. Who is the boss around here?

FACING YOURSELF

Now it gets personal: 'dealing with yourself'. Your colleagues have no choice but to put up with you. You owe it to them to have a passing shot at understanding the monster that you can be. Like it or not – and some of them will not – you find yourself in the position of leader of the outfit. There have been some shockers, occasional monsters, some who made terrible mistakes and paid for those mistakes with their careers. But there are many brilliant leaders throughout the arts, so the job can be done well, outstandingly well. What makes the difference?

It is not only worth thinking about the difference, it is essential to do so. It helps if you are nice and charming, but it won't guarantee success. It is probably better not to be an absolute bastard, but even some bastards succeed. Where do the differences between good leadership and failed leadership lie?

Good leaders will be aware that they shape their decisions and manage their behaviour around at least four sets of antitheses: short term/long term, patience/impatience, risk/failure and optimism/pessimism. (For more detail on these polarities, see Chapter 8.)

Above all a good leader has to be unselfish; a cultural manager must be merely efficient. Leading a cultural organisation is not or should not be an ego trip, though many outsiders assume that it is. The great composer and conductor Richard Strauss once told the young conductor George Solti at the Royal Opera House: 'When you are conducting in the opera house, always remember you are not there to enjoy yourself.' The same advice applies to the good, possibly the great, arts leader.

Even with that quantity of self-knowledge painfully acquired and diligently put into practice to be able to 'deal with yourself', there is a seamless transition to 'dealing with colleagues'. Without the first, the second is impossible. Colleagues cannot be ordered, patronised or misused.

You rely on them. They must trust you. The arts leaders have much to contribute: a sense of values, a sense of purpose, a sense of the whole, a sense of direction, even a sense of humour. But all their colleagues know their particular jobs better than the person heading the show. With such colleagues, decently valued, properly used, even the bad times can seem good. Matters are really that simple and straightforward.

If colleagues, even close ones, prove not to be up to the mark, still less if they turn out to be out of sympathy with the organisation's aims, obstructive even, there is usually only one option – move them on as painlessly and decently as possible. Most leaders regret holding on to colleagues who were seriously failing to contribute, were refusing to pull their weight or had actually begun to obstruct. In such events, the bullet must be bitten and is best bitten quickly. Delaying a decision when a relationship is not working only puts off the inevitable. The leader is not being a nice person when these decisions are delayed. They're just not facing the facts. The true cost of hanging on to someone who isn't delivering or even actually obstructing is very high; it is always carried by other colleagues. There is a cost to be paid for not being tough when it is needed.

WHOSE CHANGE IS IT ANYWAY?

Every arts leader has to know how to deal with change. Often a leader is defined by the change they introduce. Here, there's a choice. Whose change is it anyway? Who owns it, who initiates it, who drives it? Is it the leader, is it the management consultant or is it the stakeholder? The nature of the change will vary; so will its speed, its radicalism, its intensity, its purpose, depending almost entirely on who and where it comes from. If the stakeholder tries to tell the organisation what it ought to be and how it should behave, then the leader cannot claim to lead and is not entitled to the title or the salary. A stakeholder's priorities – especially a political one – are unlikely to be those of the arts organisation itself but rather composed of the usual bundle of half-baked social and economic wish lists that might help the politician deliver otherwise failing or misguided policies. Any leader who falls for that is a chump.

A suggested 'change programme' coming from a management consult-ant may appear more convincing. Surely consultants know a thing or two? They ought to, given the daily rates they charge. Now it is famously said, and famously known, that management consultants enter an organisa-tion knowing nothing about it; they enquire of the staff what they should know and what the staff would like to change. The consultants draw up their report, offer feedback and recommend what staff and colleagues told them in the first place. Is this worth good money?

Hiring consultants to do something you know should be done but lack the will or the guts to do yourself is pathetic. It is certainly not leadership. Should the consultants – by chance – tell the organisation something it doesn't know already, this would cast serious doubts on the competence of management and the ability of the leaders. Why didn't they know already?

Are all management consultants a waste of time? Probably not, but they are not worth anything near the fees they charge. Plot the cost of the fees against the efficiency gain from the recommendations – as any organisa-tion should – and it would often make sorry reading. Use consultants if necessary, but direct them, control them and manage them. After all, you know why they have been engaged and what problem you want them to solve. Don't let them try to reshape the organisation into something it is not and has no interest in becoming. The moment consultants start tampering with your values – about which they know nothing – or with your brand – about which they think they know everything – it's probably time to show them the door. Consultants hate organisations that don't fit their model. Chances are you won't fit – why should you? Keep it that way.

The most interesting kind of change is that generated by the leader and the team. There are two kinds of arts leaders in this context. Those who can't leave well alone, who believe that perpetual revolution is an instrument for keeping control, almost a weapon of management by fear. These are recognisable from the times they intone: 'We live in a time of change!' Of course we do, but in their case they have manufactured the change almost regardless of whether it is needed or not. These are the cynics of change, the opportunists, the ideologues, the manipulators.

Such are also usually the people who hate the organisation they are – for some bizarre reason – called upon to run.

Others are so cautious about change they can't recognise the signs of decay and sclerosis all around them. Such leaders bow down before the gods of stability, otherwise known as the lords of the quiet life.

There is a third type of leader, who works to the perhaps puzzling injunction: 'Don't just sit there – do nothing.' It involves the difference between plain inaction and deliberately adopted, masterly inactivity. Let me explain. A civil servant was explaining why his minister was trying to impose a particularly vexatious set of requirements on the institutions for which they were responsible. The civil servant made no attempt to defend the way the minister was behaving or even suggest that the policies were right. 'You must understand,' he observed, 'the minister wants to "make a difference"!' The cat was out of the bag. The policy was not founded on the needs of the sector, was not driven by evidence. It sprang from the minister's political self-interest, the evidence suggesting they might benefit from it politically. The arts in particular should be spared this ultimate political vanity, part of the fashionable insistence that a minister must leave a legacy!

How much more important is it that ministers do their job and do no harm than make a difference? Perhaps doing the job as defined and as inherited, and leaving the inheritance intact would itself make a difference, the right kind of difference.

Are there lessons here for arts leaders, given the obvious perils of inertia? Of course, 'do nothing' is the first consideration to be eliminated, or, on some occasions, to be followed. But masterly inactivity, waiting till the time is ripe, is not another form of inertia but a possible and sometimes valuable course of action, which avoids impetuosity. The use of change as an idea and as a practice in the arts needs calibrating. It is a powerful weapon; it can be an effective instrument; it should be an invigorating process. When the timing is right, when the need for change emerges from within the organisation, it can be liberating. But its use and the way it is done needs careful and subtle adaptation to the internal wishes and needs of the organisation.

DEALING WITH DONORS

Here it is well to remember the old saying, wrongly attributed to Fitzgerald: 'The rich are different from the rest of us: they have more money!' True enough, but not every rich person falls into the same basket. To engage them in supporting what you do, their motives and interests must be understood. They should be respected, actively engaged and practically involved. Donors, philanthropists and supporters need and deserve respect and study.

I suggest these as some of the characteristics of the 'new philanthropists', defined as those who have been enriched by mainly financial activity over the last two and a half decades: they have created wealth out of nothing, they are self-made, they are clever and they believe they have skills to offer that the charitable sector lacks or is frightened to use. They are very critical of, or even hostile to, state activity, which they regard as bureaucratic and inefficient. They are also in it for the fun, for being involved is more satisfying than merely signing cheques.

The truly successful donor partnership becomes indistinguishable from a friendship, defined as a partnership that is owned by both parties. These are more than business transactions expressed in a calculated balance of mutual benefit. They recognise and value a connection that has moved beyond mere computations of economic interest. It has become enjoyable. Without friendship and satisfaction, the donor connection will always remain suspicious and brittle.

To date, the full engagement of the very new philanthropists has been patchy towards funding the arts in Britain, but that is no excuse for failing to make the case for support.

KEEPING THE INNER AMATEUR ALIVE

These are big and busy agendas. Should the leader manage to put all this into practice, to pull it all together systematically, would it help in the necessary task of personal self-preservation? Or, in the welter of demands from managerialism and necessary professionalism, would

their humanity survive intact? The question posed at the beginning of the chapter remains hanging: how does one keep one's inner amateur alive? It is a wonderful question, the right question, and it can only be answered by a full understanding of a further necessary concept: 'the importance of being useless'. Unless the arts are useless, they are worth nothing. Only a fundamental amateur of the spirit can contemplate the possibility, the importance, the essential value of the useless.

Ask yourselves – did anybody ever write a 'useful' symphony? Shostakovich savagely parodied what happens if you try. You might argue that a medieval ikon or a Nativity or Crucifixion scene serves a purpose in drawing the believer's mind and heart towards divine contemplation. You might argue that Dickens' novels were useful in drawing attention to the social evils of Victorian London. Yet both Dickens and the medieval master well knew that their works would only be 'useful' in this explicit sense if they were excellent first. And this is essential. For the exemptions claimed by uselessness can only apply if the arts deliver excellence first.

To make such a claim, the relationship between creativity, learning, knowledge and application must be rebalanced. It is part of the process of reclaiming ground from the social and economic instrumentalists – those who want to stimulate class change, regenerate an area economically or perform some other admirable but ancillary activity. When challenged by government about the value of what the arts really do, of what they are worth, why they matter, the only honest and effective answer is to reply as an opening gambit: 'They do nothing, they are worth nothing, they have no use; since your government is based on the belief in utility, effectiveness and measurability, then follow your principles through. Stop funding what is self-confessedly useless!'

This obliges the proponents of absolute utility to examine their own assumptions and to look critically at their arguments.

Where do these arguments come from? There is an absolutely legiti-mate demand that those who receive public money should account for its use. The spirit and principle of democracy demands accountability too. The problem lies in the way that those demands for accountability are made. Deploying the panoply of metrical objectives ends in the creation

of the wrong types of accountability. The arts cannot answer the questions put in the form in which they are put. That does not reflect badly on the arts; it is a criticism of a certain rigid approach to accountability. It is wrong because it can only deliver a version of accountability that ends up distorting the activity being examined.

What is needed – what we all need – is a new form of accountability that does not shirk the issue of democratic openness but does connect with the nature of the activity being questioned. Put most simply, a symphony, a painting or a drama should not be examined as if its effect on its audience can be weighed, measured and counted. An orchestra can be held 'accountable' if it performs badly; that judgement cannot be made using the customary methods of evaluation.

On such a basis, accepting and valuing the fact that the arts are different, accountability can and should work. As things stand, on the basis that one kind of accountability fits all activities, it does not.

Insisting on such adaptations is, I hope, a kind of answer to the essential challenge of keeping one's inner amateur alive. Keep learning, too. What kept my own inner amateur alive at the Barbican was the sheer cornucopia of art of which I was ignorant or unaware beforehand and which I came to experience in the concert hall, the theatres, the cinemas and the art galleries. Curiosity to explore, the excitement of discovery, the stimulus of surprise, the shock of the unexpected and the arrival of the unpredicted are wonderful stimulants, necessary parts of the arts leader's survival kit.

Worrying about targets, objectives, box office, budgets, is killing stuff, soul-sapping unless you control it. Dealing with all of the business that must be dealt with can be overwhelming unless underpinned by the readiness to see the riches lurking beneath and waiting to be experienced. Everyone has to carry out the necessary tasks, the essential business. They cannot be set aside, dodged, ignored or neglected. It is vital to remember that what is done in the arts is at once gloriously useless but even more gloriously essential; the sheer weight of business drags everyone down.

5

THE WARS OF
THE WORDS:
LANGUAGE MATTERS

*'Keep it simple, keep it short, reduce the
adjectives, eliminate rather than elaborate.'*
Sir Andrew Motion

*'Never assume, once you have spoken,
that everyone understands.'*
Clore Fellow

Is there a word for the compulsion to arrange life around the letters
of the alphabet, the need to envelop one's activities within the reas-
suring parameters of that most familiar, most defining of categories?
The alphabet has authority, one that nobody in the West has ever
attempted to challenge, question or alter. Nobody has suggested reorder-
ing the sequence of the letters on the grounds that the existing order
derives from an ancient authoritarian society, that it 'privileges' the
early letters and discriminates against 'X', 'Y' and 'Z', that vowels – a
discriminated-against minority – feature too heavily in the upper half
of the alphabet.

The Roman alphabet shapes the way we think, the way we under-
stand, the way we order the world. 'A' is 'alpha', the start, the first step,
the beginning of movement, the initiator of progression, the impeller.
The mouth opens wide for 'A', a generous sound, the breath drawn in
and let out in a warm stream, a moist noise of approval.

In contrast, 'Z' is a short sound, the teeth shut, air expelled, the end conclusive. 'A' to 'Z' encompass the way we think about life, experience it, understand it and try to explain it. In between, the letters of the alphabet provide an opportunity for definition, a route to explanation, a set of pillars on which to build understanding. It is one of the few expressions of completeness that we have: numbers go on to infinity, but the Roman alphabet remains constant within its 26 letters. Its varieties are endless, yet its apparent solidity and restriction are reassuring. Everything can be contained within the magic 26; it follows that the wish to explain some part of our lives – if we have such a wish – by expressing them in alphabetic form amounts to a cry for completeness – understandable – a search for order and system – reassuring – and ultimately for a kind of legitimacy – which is validating. It may of course just be a compulsion, a neurotic twitch or a game – we have all been taught the importance and value of play in the most serious matters.

At all events, I plead guilty to the compulsion to seek completeness, reassurance and validity in my occasional impulse to 'alphabetism'. If it is a condition, it is not worth curing. It is certainly a form of play worth playing.

I have indulged myself in 'arts alphabets' on two previous occasions. In *Art Matters* in 1999 it took the form of the chapter 'The A to Z of running an arts centre', mainly a lexicon of all the activities then involved in managing a major arts venue, a necessary reminder of the sheer and growing complexity of such an undertaking. New words to explain new responsibilities in the arts were creeping in. To say in 1999 that 'A' was for 'access' and 'accountability' was to acknowledge the more complex world that the arts were beginning to inhabit. The letter 'C' heralded both 'commercial' and 'catering', which were not the preoccupations that they are today. The letter 'O' pointed to the increasing awareness of 'outreach' to schools, to audiences, to non-attenders even, a very new thought. By including 'utopia' and the 'unexpected' under 'U' I was nudging myself and others away from the new complexities and urgent practicalities of contemporary arts management and back to the real substance of life. If the arts weren't reaching for utopias and revealing the unexpected, what were we about?

By 2007, in *Engaged with the Arts*, my 'New ABC of the arts' showed a darkening of tone, a hardening of line, a growing intrusion of alien concepts. This was unexpected and as a result rather useful for its insight into a world still changing and doing so in new ways.

An entire new alphabet had wormed its way out of the corners of Whitehall bureaucracy to try to stop the arts world from doing what it really needed to do – provide wonderful art. What this new alphabet showed was how far the arts world, the way we looked at it, the way we ran it, had been transformed yet again within a few short years. It had not been transformed in its own terms, but rather in the concepts by which it was judged, managed and evaluated. The creative fertility of the bureaucrats had an unstoppable energy of its own.

A CHANGING WORLD

What the 'New ABC' of 2007 perhaps unwittingly revealed was the growing intrusion of 'managerial' concepts into the arts. The word is in inverted commas to signal that the very process of employing managerial nostrums – useful or not as they might be one by one – became a quasi-ideology which its acolytes proffered and tried to impose as a necessary and sufficient method of running organisations to the exclusion of other values or ways of thinking.

In the world of 2007, 'A' inevitably started with 'assessment', where every organisation was examined, scrutinised, quizzed, questioned and bothered in the name of efficiency and effectiveness. But when 'D' summoned up – accurately – 'delivery' and 'direction of travel', the world was changing. By statement or implication, an arts organisation did not present theatre, mount opera or put on exhibitions, it 'delivered product'. Was it successful or not? That depended on its 'direction of travel'! With 'G' heralding the newly emphasised activity of 'governance' – how any organisation was supervised – and 'I' revealing the long and bitter culture war about 'instrumentalism', where the arts were deemed to be worthy of subsidy principally if they were socially or economically useful, we were indeed in a very different, alien, even alarming place.

The debate had changed and broadened beyond a game about words and letters and into a fully fledged engagement by both sides about language as a political and philosophical weapon, its uses and the way it needed to be protected and defended by the arts world.

The debate over the use of language has not diminished. It continues today. How should the engagement about vocabulary and definitions take place? Certainly, the need to find and use language about the arts that belongs to the arts is as great as ever. How should it be defined? Time to return to some basic definitions, to draw up the lines of verbal resistance, for resistance is needed against what are alien encroachments.

THE WAR OF WORDS

The language of the arts must not be the language of management, business or the civil service. We need our own words to define our needs and activities, not an externally imposed lexicon of objectives, outcomes and deliverables in which a sense of purpose becomes a 'direction of travel', a difficulty always becomes a 'challenge', a dilemma mutates into an 'issue', serving your audience becomes 'maximising stakeholder value', and clarity and meaning dissolve into fogs of evasion or obfuscation.

For 'policy' is nothing but 'What do you want to do?' 'Vision' means simply 'What is your big idea?' 'Process' signifies 'How will you do what you want to do?' What are 'outcomes' but 'results'? What is 'risk analysis' but spotting dangers? Raising objections to managerial cant is not in itself mere pedantry. The lack of clarity of faux-managerial words and concepts not only has the effect of undermining meaning: it is intended to do so. Were the arts to adopt this vocabulary it would amount to no less than capitulation – an intellectual surrender first, closely followed by surrender of independent action.

Make no mistake. The pressure on the arts from some funders and policy makers to use these alien terms and concepts is often considerable. It is far easier to wrestle an opponent to the ground when the terms of the debate are yours. The first task of the arts world is to refuse to be bullied into using words and concepts that belong to a different world – the

world of bureaucratic jargon and management speak. The arts must be – and are – clever and cunning enough to know how to use and adapt management tools to their own purposes. But to do so is only part of the process of being excellent, not a guarantee of excellence, still less a guarantee of completion.

STICKING TO YOUR LANGUAGE

All too often arts organisations, especially small ones, fear resisting or challenging proposals that come from another intellectual universe. The real lesson from Whitehall is that bureaucrats and policy makers only respect those who resist and fight back. It is the law of the jungle – the weak and frightened are pursued and mauled; the strong are respected and accommodated. Ask any retired Whitehall veteran and they confirm that this is the prevailing mindset, the tactic of first choice. Commanding your language, sticking to how you speak, how you think, how you act, is a key element in striking and maintaining this defiant posture. There is nothing negative in adopting such a posture; defiance is far more than defensiveness, far stronger; defiance indicates a belief in ultimate success.

There is a particular language in the arts, unique perhaps, certainly special and distinctive. That does not make it better – intellectually or morally – than other languages. It does not originate from a position – implied or assumed – of superiority over others. It matters because it describes and expresses what the arts do better than other languages.

What might this language, what must it, include? What must it be allowed to express? That the arts are unpredictable in the effect that they have and the time span over which they are judged may be decades away. That failure in the arts is frequent and cannot be prevented by advance planning and that excellence cannot be guaranteed. That an activity which deals in the original or even the revolutionary must not be judged by snap decisions; that value for money emerges years after any expenditure takes place. Above all, that giving the arts a chance to be excellent, which involves chance, risk and harnessing the variable, the impulsive, the uncalculated and the shocking, depends on allowing the arts their

own voice. They must be able to talk of what they do, argue for what they do, explain what they do in their own terms. How can the arts be judged, appreciated, measured except in a language which is rooted in their fundamental complexity?

Above all language should not be imposed from outside as a straitjacket. It is not about power, the imposition of policy, of social or economic prescriptions. If the arts are to free themselves to do what they are best at, they must reclaim the way in which they talk of what they do. The war of words, the war about words, must be fought.

Words must be recognised as slippery, ambiguous, rich and risky. They should be used with care precisely because they are powerful and dangerous. At their best they can change minds. Often they are the only weapon the arts world has. That is why they are worth using carefully and considerately; meaning is at stake. Preventing misuse, obfuscation and distortion requires eternal vigilance. Being picky about the way words are used is not pedantry. It is the first line of the defence of truth. Capturing the vocabulary amounts to a first line of attack.

In 2012, it was time to test the waters, to examine the intellectual zeitgeist by addressing the alphabet again, searching for an alphabet, or elements of it, embracing words for our times. This time I had partners in the process – the current members of the Clore Leadership Programme, the Clore Fellows. How did they respond to the words that surrounded them and their activities across a wide range of the arts? As I offered my own critique of objectionable words, the fellows joined in wholeheart-edly. Teasing our way through the alphabet was presented as a game but it was a game with a serious purpose, a game about words and concepts and about the use of a whole language too. Starting with my current list of abominable words and concepts, how would others respond?

My opening was the suggestion that 'accountability' and 'assessment' fell easily into the abominable category, 'assessment' because it is employed as a justification for excessive intrusion and attempts at supervision. Both threaten the operational independence of the organisations assessed and do so in the name of public 'accountability', as if an external body is the right instrument for exercising such accountability. What accountability

does is undermine the responsibility of the organisation involved. Without the exercise of responsibility, independence is undermined. Without independence based on responsibility, any organisation becomes an instrument of others.

In reply the fellows shared the dislike of 'accountability', but added to the list the ugly jargon of 'additionality' and the pretentiousness of '*animateur*'.

My own instinctive and practical rejection of 'bureaucracy' under 'B' struck no echoes with the audience, for whom it carried no negative connotations; instead they associated it with the necessary practices of proper management. They threw their active dislike behind 'benchmark' − a reductive notion that eliminated creative differences and variations − and 'beneficiaries' − a harmless enough word to my mind, but one with patronising overtones to theirs.

We shared a strong dislike for the flattening reduction of individuals in any form of service relationship into one kind of category − that of 'customer'. Gone are 'audience', 'listener', 'viewer', 'passenger', 'patient', 'traveller' or any of a dozen different activities and relationships that define a myriad of distinct and particular transactions. 'Customer' is literally a 'one size fits all' concept diminishing particularity and difference, dehumanising people too into one type of exchange. Most agreed that any activity that started to call and treat its users as 'customers' rapidly spiralled downwards to the point where it produced inferior service.

They were less responsive to my suggestion that the well-nigh universal category of 'consumer' also eliminated difference. I argued that members of an audience might indeed 'consume' because they bought and paid for tickets, but that this was a grossly limiting view of the nature of paying for and attending an arts event. The fellows directed their dislike towards 'capacity-building', which sounded grand but was impossible to define in a sensible way. They hated 'connectivity' − a pervasive neologism of digital-world origin and usually misused when the simpler 'connection' was really meant. The ghastly and still comparatively rare neologism 'coopetition' − yes, 'cooperation' and 'competition' − was treated with contempt as at once ugly and meaningless.

There was quick and ready agreement to endorse my dislike of 'direction of travel', generally derided as pompous and actually useless as a help to action. Other 'D' words heartily rejected included 'digital' – didn't everybody live in the digital world? Perhaps they don't need reminding. There was wariness about 'driver' – recognised as meaning far less than it seemed to claim. Hackles were raised by 'discourse' – regarded as a pretentious, poshed-up kind of word to describe discussion, debate or any kind of extended intellectual exchange.

We ran into a fundamental disagreement during the letter 'E'. I assumed we would agree that 'elite' was a lazy piece of political name-calling, closing down argument and discussion about the value of difficult arts and therefore to be abjured. The fellows defended it as a term of approval close to one of their other favourite words of approval, 'extraordinary'. How or why they could endorse 'elite' but would react strongly against 'excellent' – banal and overused perhaps? – puzzled me.

But I couldn't quarrel with their otherwise lengthy hate list of 'E' words: 'edgy', 'engage' – why not 'get involved'? – 'experiential' – meaning offering or having an experience and combining obscurity with the pretentious. The fellows dug up another ghastly new formation: 'edutainment' – yes, combining 'education' and 'entertainment' – which deserved only to be immediately reinterred.

Our discussion stalled when we came to 'F'. What was there to hate? I offered the compromise of a very common phrase that at least had the letter 'F' in it – 'going forward'. We united in abomination of the phrase regardless of where exactly it stood in the alphabet.

For the letter 'G', I had offered 'governance', not because I dismiss or undervalue it. I have become something of a zealot for good governance after experiencing more instances of the consequences of bad governance. My colleagues showed no interest in governance – perhaps reflecting their comparative lack of experience in its depths. Instead they focussed their dislike on the use of 'great' – just plain lazy and often wholly untrue of those who claimed it for themselves. They rejected 'goals' as redolent of management speak and therefore alienating.

Interestingly, the fellows were strong in rejecting that once fashionable

concept, 'green', on the grounds that it was moralising, postured as superior and presumed itself to be beyond challenge. 'Gravitas' died a death as pompous, complacent, self-regarding and self-satisfied. As for the contemptible 'glocal' – probably carrying the sense of 'think global but act local' – if the notion was worth exploring then it certainly deserved examining at length rather than suffering compression into a jarring non-word.

THE MADE-UP WORDS

In passing, we should beware of these manufactured words – 'coopetition, 'edutainment', 'glocal' – noting that most of them derive from dubious sources: consultants, marketing, and suchlike. Few people have the courage to challenge or question a new word or concept. When faced with such 'newspeak', scepticism and challenge are essential. Few of these confected words survive the test of time beyond the original seminar or report where they were first unveiled. Brownie points to the consultant that invented them; bottom of the class to anyone who believes them or uses them.

As we trod our way through the alphabet, we had no difficulty in collectively jumping on 'holistic'. This was felt to be another grand-sounding word inviting approval of an elevated underlying concept but meaning less than 'taking many things into account together'. Speakers who use 'holistic' are usually trying to bolster a threadbare argument. How can anyone reject a 'holistic' approach? Easily, since it means less than it claims.

I found myself isolated at the letter 'I' in worrying about 'impact' as in 'impact studies'. Here intellectual or artistic activity must demonstrate its case for support by proving in numerical terms that it yields a real 'impact' for society, usually social or economic. 'Impact' is actually 'instrumentalism' dressed up in new clothes, and that was rejected long ago. However, the fellows were united in ganging up on 'indicators', largely because they invariably 'indicate' the wrong things to the wrong people, and do little to determine the health of an arts organisation.

At this stage in the alphabet, the responses became more random but without losing their critical edge.

I offered 'legacy' as 'one to watch' and beware of. It was increasingly deployed as a wrap-around word to demand support for a long-term project that it usually failed to deliver. Some held up 'leverage' for rejection because it felt like someone exerting pressure on another using self-assumed authority. Others dismissed it as a relic of the dot-com boom, when university vice chancellors tried to make particular projects greater than the sum of their parts. One scientist fellow vented exasperation with the misuse of 'labs' with which the arts world is littered. 'A lab is a place for controlled experimentation,' she raged, 'not a place to play in!'

Dislike of the word 'narrative' was widespread, seen through by all as an overblown word for good old-fashioned 'story'. It is sadly rampant in certain quarters. When I heard an interviewee saying that he had been advised by his HR director to improve the way he 'edited his personal narrative' – that is, 'talked about himself at interview' – it was clear how far this rot – in every sense – had gone.

I held up 'respect' for critical scrutiny. In its useful form, the notion of affording another person 'respect' has always been an essential part of socially considerate behaviour. In its contemporary overblown sense it has come to mean everything from not kicking another footballer to not insulting someone, not bullying, not exploiting, and tolerating the intolerable on the grounds of multicultural sensitivity. In short, a range of disagreeable behaviour has become subsumed into a blanket concept that shies away from the real nature of the social or physical offence. In its older usage, 'respect' is consideration, gentleness and care. In its portmanteau form it flattens out misbehaviour, diminishes its strength and reduces its impact.

The fellows produced a surge of dislike for 'synergy'. In my book it is a purely hopeful, pre-emptive word, inviting support for actions that claim to deliver hyped claims of success. 'Synergy' is usually claimed and prayed in aid to justify an expensive project. Whether 'synergies' are delivered is rarely examined after the event. Some fellows were scarred by memories of higher education in the year 2000 when vice chancellors gave large amounts of money to start-ups on the grounds that they would 'deliver synergies'. They rarely did.

Staying with the letter 'S', one fellow singled out the marketing cant of 'segmentation' for opprobrium, charging it with the 'death of individualism' and representing 'monolithic thinking for target groups'. Another observed cynically but not unfairly that 'sustainability' was perhaps the buzzword of buzzwords. On this view it is a profoundly dishonest concept inviting approval for its apparent virtue but actually meaning 'Carrying on doing it when we've stopped giving you money!'

At the letter 'T' general abomination enveloped 'transformational' – which it very rarely proved to be. Close by in the alphabet, 'pushback' was spotted, defined as a 'faux-polite' version of 'resistance', 'argument' or 'disagreement'. 'Route map' was judged to be suitable for military manoeuvres no doubt, but not for arts organisations, which face utterly different types of complexity. In this context the celebrated 'fog of war' – confusion and unpredictability on the battlefield – is as nothing compared to the 'fog of creativity' – necessary uncertainty and volatility in the studio.

There were many more words to abominate than to like and admire. That was and is the nature of the game, the best kind of play. It is a necessary reminder of the fierceness of the contest in the search for decent meaning, clear expression and honest argument. Our vocabulary – the vocabulary of the arts world – should remain ours. It should also recognisably be the language that audiences use. It must not be hijacked by or surrendered to the language and professional evasions of management speak, bureaucratic gobbledygook or political doublespeak. As the former Poet Laureate, Sir Andrew Motion, advised on the writing of poetry, 'Keep it simple, keep it short, reduce the adjectives, eliminate rather than elaborate,' which is good advice for all forms of expression and the way we use language.

For words alone are not sufficient. They need expressing in ordered thought. Words are the essential starting point, and unravelling their meaning and deploying it in planned argument becomes the first task. Distorted words, debauched words, overblown words must be guarded against and preferably rejected. Using our words to describe, define, account for and defend what we do in our language – that is today's task and tomorrow's duty.

SOME ABOMINABLE WORDS

- **A** for Accessible, Accountability and Assessment.
- **B** for Bureaucracy, Benchmark and Beneficiaries.
- **C** for Customer, Consumer, Capacity-building and Connectivity.
- **D** for Direction of Travel, Drivers, Digital and Discourse.
- **E** for Edgy, Experiential and Edutainment.
- **F** for Going Forward.
- **G** for Goals, Green, Gravitas and Glocal.
- **H** for Holistic.
- **I** for Impact and Indicators.
- **L** for Legacy and Leverage.
- **N** for Narrative.
- **P** for Pushback.
- **R** for Respect.
- **S** for Synergy, Segmentation and Sustainability.
- **T** for Transformational.

6

LEARNING ON THE JOB: A PERSONAL ROAD TO RESPONSIBILITY

'How do you know where you are going if you don't know where you have come from?'

Clore Fellow

'I want to find out things I don't know – it could be frightening.'

Clore Fellow

Experiences of leadership come from all directions. In retrospect the odder they are, the more useful they turn out to be. They seldom look like lessons in leadership at the time, especially to the young. Much later they emerge as having a value that they didn't seem to possess at the time. Like other personal attributes they make a future leadership style what it is as well as what it isn't. At the time, I didn't realise that I was absorbing lessons in leadership from my father, from the army during National Service and even from the upper echelons of the BBC as a general trainee. But I did and may have been putting them into practice, at first unwittingly, later more consciously, for years.

My father's leadership style was all around us at home; make no mistake, it was about 'leadership'. As managing director of the British Bata Shoe Company, improbably based on the Essex marshes at East Tilbury,

he had been trained in charismatic leadership – though no one would have used or even recognised the term – by the founder of the Bata shoe empire in Czechoslovakia, Tomáš Bat'a. The latter's style can only be adequately described as highly personal, highly paternalistic, highly intrusive and highly visible. His bronze, more-than-life-size statue still stands at the heart of the now closed company estate in East Tilbury. Bata's management philosophy and leadership style were exported wholesale from the southern Moravian town of Zlín, where the enterprise started, to a previously desolate part of the Essex marshes bordering the Thames Estuary. This was the enveloping atmosphere in which our family lived: a company family on the edge of a company town. It was always more than a background to our lives.

Childhood memories are not inaccurate, but they are importantly selective. On many occasions at lunchtime – my father always came home for lunch – the talk was of how he had 'played hell' with some person or group that morning at the Bata factory. 'Playing hell' was undoubtedly part of the Bata management style and lexicon, a way of putting mistakes right, keeping people up to the mark and not tolerating waste or error. My father's predecessor was famous for starting the daily production review meeting by entering the room devoted to shoe samples and hurling them around to underline his criticisms of quality. Regular attenders invariably took up a position close to a convenient table to seek shelter from flying shoes. My father never went that far. But some of that robust approach – like the shoe missiles – was in the Bata management air.

The chief instrument of torture, as I sensed it, was the company's 'Friday luncheon conference', at which all finance, production and retail-sales numbers were reviewed and those responsible had to explain why they had missed their targets. Some of those who fell short received what was called the 'playing hell' treatment, though on the single occasion that I attended it seemed a tense but decently mannered event. But nobody could shirk responsibility for their results. Woe betide them if they tried. I never understood why the incidence of stomach ulcers among Bata managers was not far higher.

THE PAGAN CHRISTIAN FEAST

The weekly gathering was of course about accepting personal responsibility. This was experienced at home above all on Christmas Eve, a feast Czechs and central Europeans celebrate instead of Christmas Day. A regular family guest was the Bata retail-sales manager, as a friend as well as a colleague. Two-thirds of the way through the great celebration meal, the manager would be summoned to the phone to receive the sales figures for the vital Christmas fortnight. They were usually good enough not to cast a pall over the evening. Thanks were duly and openly given to the Almighty – both for the sales results and no doubt for the feast of Christ's birth – glasses were raised, the meal finished and gifts could then be distributed. Even as a boy, I thought it added up to an odd hybrid act of observance, part pagan and materialistic, part Christian, but perhaps no odder than thanksgiving for a good harvest.

If rigour about performance and high degrees of personal responsibility were abrasive parts of the Bata management style, others were more emollient. The Bata style involved 'management by walking around', practised in all their factories decades before it was coined as a magic managerial nostrum. My father 'walked' the entire plant on a weekly basis. He knew the names of perhaps half of the 3,000 employees at Bata East Tilbury and recognised even more. Walking around, being seen to walk around, observing and talking to staff: these were powerful management tools. Interestingly though, they were not seen as such but regarded as merely good behaviour and certainly as good manners. Decent behaviour was seen and practised as entirely compatible with robust management discipline.

More problematic was the implicit expectation that the company should be the most important part of life. Commitment seemed to me to be admirable, but its domination of the rest of life was far more questionable. The positive lesson was that identification with the place and people you worked for and with was probably a good idea; you were fortunate if your organisation was worthy of such commitment. But if some of your body, a goodly part of your mind and most of your time was spent on work, your

heart and soul had to be free to roam more widely. That was both a lesson and a warning. Once he retired from Bata, my father was lost, at sea, cast off from the only moorings he had ever had. It was very sad. There might have been something admirable in such lifelong loyalty to the institution but I concluded that no institution, however remarkable, deserved such total, unconditional, all-engrossing loyalty. It would never be repaid in equal measure. Institutions have no sentiment to them, certainly allow no room for sentimentality. Such awareness from childhood and youth lay dormant for three decades. Then it turned out to be surprisingly useful.

I witnessed another model of leadership during my National Service in the Royal Artillery in 1954–6. It was very different from Czechoslovak paternalism, and was unveiled on this occasion more explicitly. Anyone considered for a commission as an officer – and almost anyone with five O levels fell into this category – was required to show that he possessed 'officer qualities'. As I recall, these qualities were never specifically defined. You either had them or you didn't. At the War Office Selection Board (WOSB), where possession or non-possession of these qualities was observed and tested as a condition for proceeding to officer-cadet training, I inferred from the exercises and the tests we were put through – 'There are no trick cyclists here!' we were reassured, whatever they were – that the desired 'officer qualities' included initiative, energy, enthusiasm and some brain. Implicit and unstated of course was a readiness, indeed a determination, to 'go first', to 'lead from the front'. In the then peaceable times of the early Cold War this seldom threatened to transfer into being killed first (though it did for some of my contemporaries). Only those possessing at least those five treasured academic O levels – and most did not possess them – were deemed likely to possess these more human qualities.

UNRELIABLE LESSONS

If such theoretical models were both unsurprising, indeed almost predictable, the examples offered to us officer cadets by serving commissioned officers were more surprising and even at the time seemed far more questionable. One major pronounced – this was 1955 – that 'a gentleman

pays his tailor's bill last'! Another offered that 'a gentleman shaves every morning in the morning', a rebuke to those of us who in perishing weather and poorly heated 'spiders' – flimsily built dormitory huts at Aldershot Barracks – were trying to ease the morning rigours by shaving the previous night. Perhaps the most recherché guidance ever given to officers was received by a friend on the battle-strewn landing beach of Salerno in Italy in 1944. As the troops regrouped before a further German counter-attack, the commanding officer ended his orders by saying: 'And kindly remember, gentlemen, in the event of a royal decease, no pink for hunting!'

At a more skills-based level, the military mantra that 'time spent in reconnaissance is seldom wasted' might not amount to a guide to leadership, but has been a deep and useful lifetime reminder of the folly of precipitate action. If I have been guilty of ignoring it on occasion, and on occasion I have been condemned as being 'pathologically decisive', I have never failed to recognise its intrinsic wisdom.

It was only while serving with the Royal Artillery in West Germany in 1955 that a real lesson in leadership came my way. As we finished a day of exercises on Lüneburg Heath in northern Germany, the battery began to settle down in its overnight camp. My battery commander said: 'Always make sure the men are fed and billeted first; you come second!' I can't recall if that was a direct and necessary rebuke or merely an observation. But it struck home as it was meant to do, my very first lesson in the practice of good military – or indeed any – leadership. People for whom you are responsible come before you. Years later when I confessed the extent of such poor practice to my son, who has a military background, he observed: 'It is one of the oldest military maxims: "Horses first! Men second! You last."'

These gleanings too were to lie fallow for some decades. I did not recognise them as clues to leadership, guides perhaps, mantra certainly. Particularly, I found them of little relevance during my early years at the BBC as a general trainee, one of an elite group with supposedly major destinies ahead of us. The group was revealing of the assumptions of the time, the year 1960. Of the ten chosen for this elite status, only one was a woman, the first ever to gain selection for the scheme. Only one was

non-Oxbridge, again the first to break through the 'twin rivers' charmed circle. It was clear that leadership qualities resided here, in the two 'great' universities, with just the minutest leavening from women and the north.

This was certainly a grand assumption, that leaders were precreated by education and environment, that leadership was innate, that you either had it in you or you did not. For there was no discussion of leadership at all – or even management, come to that – during the three months of sessions at BBC Staff Training or during the BBC-wide secondments that followed. Nor did this omission, glaring to today's eyes, seem important. Leadership, it was assumed, was an attribute either possessed or to be absorbed. It could be picked up through experience, inferred from actions or passed on through example. The examples to follow were supposedly on offer all around us.

It may have seemed self-evident that the BBC's first director general, Lord Reith, was a 'great' leader because of his rugged purveying of standards and principles, his unyielding, high-minded righteousness, not to mention his profile. This was the leader as Old Testament patriarch, quick to anger, swift to condemn, difficult to live with, impossible to satisfy, easy to displease, dangerous to challenge. If Reith were a piece of history, part of the furniture, in the very air we breathed, he was undoubtedly a period piece as a potential model for leadership in 1960. But was there a viable, more available alternative to follow?

BACKING YOUR STAFF

For many of us young producers of the time, the example of Hugh Greene as director general was altogether more persuasive and acceptable. As a fearless journalist Greene embodied the principles the BBC stood for as a whole. He was absolutely 'on our side' as broadcasters; his values were our values; he was fiercely independent of government, even apparently cheeky to them on occasion, as in his commitment to television satire shows such as *That Was the Week That Was*, which broke new ground in political and institutional irreverence. This was leading from the front. It was good and easy to be able to follow such a lead.

Elsewhere in the BBC, the example of the effective leader proved much harder to find. Many from whom an active example was expected were remote, even reclusive. I knew one departmental head who never left his office and whose secretary brought him lunch on a tray to be consumed in private with the curtains half drawn. On another occasion, while being interviewed for a book about the BBC by an Edinburgh sociologist, we passed in the corridor at Broadcasting House a distinguished senior figure in radio. Despite having himself been interviewed recently by the academic, the senior figure scuttled past, head lowered, with barely a nod. My academic companion expressed surprise at what could have been a snub. I protested loyally that X was 'known to be rather shy'! The academic nodded: 'You would be surprised how many senior people in the BBC are said to be shy.' It seemed then and now a poor model for leadership of anything, at any time. Shyness cannot be a privilege of the leader.

As a working broadcaster, first within the BBC, then outside as a freelance, I found myself – with my colleagues – at the receiving end of variable management styles and fluctuating approaches to leadership. This too was a valuable part of learning by experience. The lessons were often discomfitingly clear. Those who did what had always been done, who worked by standard procedures, who stuck to the predictable, who feared the different, who were alarmed by the original, were demotivating to work for, depressing to be with and ultimately demoralising. Sometimes such were described – praised even – as a 'safe pair of hands'. Many were promoted. In fact they never delivered 'safety' – but they certainly delivered stagnation. When promotion for these inexorably followed, mere broadcasters looked on aghast and felt betrayed.

There were lessons to learn. The BBC did allow and occasionally recognise leaders who broke the rules by creating new ones, who advanced practice when custom and practice stagnated, who led publicly by example and vocally and who defended their actions personally without the restriction of the deadening hand of caution from media advisers. One such was my first boss at the General Overseas Services, Gerard Mansell. French by birth, Mansell provided an example of rational, intellectual judgement in journalistic editorial matters that set values throughout

Bush House. Later he – aided by the former *Daily Mail* editor, William Hardcastle – broke the mould of the old Home Service and created the format, style and approach for Radio 4 – principally *The World at One*, the hard-hitting, opinionated, thrusting, urgent news programme that has commanded the daily news agenda for nearly 50 years.

Later, one of my oldest friends, John Drummond, controller of Radio 3 and the BBC Proms, led both with an extrovert flamboyance that undoubtedly sat easily with his character but was always deployed in the service of the network and the music and the arts that he loved. Both in the BBC and as director of the Edinburgh Festival, Drummond commanded huge personal loyalty. He also served as a warning: his no-holds-barred intellectual combativeness, his refusal to suffer fools at all, delighted those who worked with him but also won him many public enemies, who increasingly did him no favours when he came to need them. Having some enemies is a badge of distinction; having too many appears like recklessness amounting to indulgence, and comes with a cost later in a career.

In television in 1980, real courage and radicalism without recklessness was demonstrated by George Carey, who conceived and created BBC2's *Newsnight*, at first regarded as an impossible hybrid of news and current affairs – and never the twain should meet! The broadcasting unions were opposed and tried to set impossible terms for two different kinds of journalist, the first from news and the second from the more speculative current affairs, in their archaic definitions, to work together. The BBC executives, under the director general, Alasdair Milne, did not care if the programme got off the ground or not and would not fight for it. As founding editor, Carey persisted, fought the union battles and started a programme that has lasted for more than 30 years and represents a kind of broadcasting format regarded as essential in the programming pattern. *Newsnight* adopted its own portfolio of values and approaches. It was part analysis, part reporting, part exposure, but all leavened with wit, humour and fundamental irreverence. Without Carey's leadership it would not have happened.

But there seemed no consistency to the emergence of such leaders, no coherent philosophy behind it, no understanding that true leadership was a necessary part of the BBC's own evolution. If a dynamic leader emerged,

well and good; if a stodgy one replaced a previous stodgy one, well, worse things could happen. It took the BBC many years to understand that the deep institutional consequences of such a laissez-faire attitude to its senior managers would be a recipe for near disaster. For those working under and within the system, good programmes were made despite such managers, seldom because of them. They often actively held back innovation and good work; they rarely contributed to its realisation. These too were lessons observed, considered and to be learned.

Throughout my years of freelance broadcasting work, I neither received nor sought training in management or leadership. Little was available, management theory itself was evolving, much of it felt remote from actual practice, and there seemed no point in undertaking training at my own expense when I expected to remain a live broadcaster for the foreseeable future, perhaps for my entire career.

ENDING MUSICAL CHAIRS

The fact that I became a senior executive and editor in the BBC in 1986, as managing director of the BBC World Service, with no prior experience of running or editing anything, takes some explaining even to myself. Looking back, three things worked in my favour. First, the chairman of the BBC, Stuart Young, was tired of the high-level 'musical chairs' practice that seemed to operate within the corporation whereby the top executives shuffled from post to post almost as a matter of right and habit. Second, having worked in or around the BBC World Service for my entire career, I knew it professionally. More than that, and third, I knew what its values were, I had adopted them as my own and my clear identification with and articulation of those values made me – in Stuart Young's mind – a credible candidate. He decided that I could learn the rest of the management portfolio later. His was a leadership decision of a high order, putting understanding an organisation above the practices and routines of running it. For him, an institution's values came first.

As managing director of the BBC World Service from 1986, learning about leadership and management had to be fast. The director general,

Alasdair Milne, provided a textbook lesson in how not to manage his supervisory board, the BBC Board of Governors. It was an early lesson in the pitfalls of governance. Milne ignored the warning signs that the governors were deeply unhappy with his handling of a major row with the Conservative Party over a 1984 *Panorama* report called 'Maggie's militant tendency', which alleged right-wing infiltration of the Tory Party akin to the Trotskyite would-be takeover of the Labour Party in the early 1980s. The MPs concerned sued the BBC. The case was heading for the courts. Milne remained blandly reassuring: it would, he stated repeatedly, be 'settled on the steps of the court'! The governors did not believe or trust him. He was summarily sacked after a board meeting in January 1987. Milne never saw it coming ahead of the meeting; everyone else did. I concluded that he 'lacked a sense of danger'. A tragedy for him, it was a salutary lesson for me and others. Never be complacent about your position; never be taken by surprise.

Over the next six years at the BBC World Service, I found myself putting into practice most of what I had experienced obliquely through a lifetime but whose value I had not fully appreciated. There was much else to learn, including the value of the random gleanings, observations and detritus of the experiences of life. From my father, regular walking around, visits to the canteen, recognising colleagues, knowing names, taking responsibility, committing to an organisation but not selling your soul to it. From the army, looking after staff first, taking thought before acting. From Hugh Greene at the BBC, leading from the front; from Alasdair Milne, recognising the smell of personal danger. From the BBC as a whole, leading from values, not being shy, abhorring stagnation.

There were others too. To those who unwittingly scattered these and many other wise axioms – gratitude. How I used them has been my responsibility. Very little has gone to waste.

And gleanings of wisdom appear from unlikely sources. Recently, a street tea vendor in the Medina of Tunis sold us a glass of mint tea. As we finished, he offered another. As we appeared to wish to hurry on to the next site, he chided me gently, '*Doucement, doucement!*' – 'Gently, Gently!' He is right. That too is part of leadership.

7

THE LEADER, THE MANAGER: WHAT'S THE DIFFERENCE?

'Leadership must be uncoupled from management.'
Clore Fellow

'You can't aspire to mediocrity.'
Clore Fellow

Sitting around the conference table at a meeting with strangers, the glances of mutual assessment are wary, cautious, carefully concealed, but searching for clues. In the arts, business or politics, the human responses are identical. All institutions share such behaviour. Judgements have to be made. Who is who in front of you at this meeting? Who is powerful? Where are the egos? Who is holding him- or herself in reserve? Who will lead a charge? Who holds him- or herself back for the second attack? Does one operate on a short fuse? Does another have the stamina to endure? Who makes eye contact? Who looks down, avoiding it? Such information is gathered within the first seconds of sitting down. It should never be ignored or overlooked.

Most of these will prove to be tactical judgements, useful perhaps but probably not decisive. Behind them lie the deeper questions that search for the strategic awareness of the partners, opponents or clients across the table. Who is the leader, who the manager, who the bureaucrat? It

is a waste of time to negotiate with a bureaucrat, argue details with a leader or float a vision with a manager. Each has his or her role, function and skills. Remarkably, the differences are fuzzily defined, poorly understood, confusingly implemented and inadequately embedded into the organisation.

Pity the organisation or institution that appoints a manager to be a leader, an instinctive bureaucrat to be a manager or hopes that an obvious leader will also be an effective manager. For these are distinct types of people, defined by instinct, temperament, outlook, knowledge and skills. Not knowing the difference between them, not valuing the difference between them, not using the differences to make the best result for the body they run can lead to expensive failure, even disaster. Leadership, management, bureaucracy – they are very different activities.

For a start, a leader is not better as a person, as a human being, than a manager or a bureaucrat: all have their place in the running of the institution. Behind every great leader there stands a good manager; behind the manager lurks the instinctive bureaucrat. Every leader must have some managerial instincts to make dialogue with their managers comprehensible. Managers do not need to be leaders in the whole sense, though they should understand how a leader's instincts work to get the best out of him or her. Both need to use the bureaucrat's skills to make sure the foundations of their plans and vision are sound. Neither should waste time talking of vision with a bureaucrat. It will not be understood because these notions stray beyond the known, the predictable, the assured.

It is vital to define, to understand and to work out these distinctions in practice. Many are surprised that they are as different as they are or that they are even different at all. To some they are merely three words that point to slight but unimportant differences: in pay grades, specific places in the hierarchy. They could not be more wrong.

BEING, DOING, KNOWING

Essentially the three functions divide like this:

- leadership describes what you must be to help an institution fulfil itself and all the things you must know to make it work;
- management is concerned with what you must do to run an institution properly;
- bureaucracy is responsible for knowing the rules by which an organisation operates and what you must know to obey them.

The implications and consequences of such distinct sets of behaviour, outlook, inclination and skill are profound. If recognised they serve to identify particular areas of responsibility for each function. If neglected or not understood, confusion or conflict occur and the organisation will underperform or move in wholly wrong directions.

Leadership is responsible for the effectiveness of an institution, the way in which it behaves overall, the sum total of its ideals, its skills and its physical and artistic capacity expressed and judged as a whole.

Management delivers the efficiency of an institution, an essential building block in its effectiveness and important public evidence of its ability to use funding properly. Efficiency is a necessary indicator of institutional health. It is not sufficient to build a creative institution. If an arts organisation were merely efficient, it would lack the further dimension that distinguishes it as an effective one.

Bureaucracy, if left alone – and some organisations fall into the trap of believing that efficient bureaucracy is sufficient in itself – leads only to inertia and frustration. A rule book is no guide to leadership or management but rather a set of inflexible prescriptions. It ties down initiative, imagination, ambition and curiosity, and ultimately blocks achievement. Bureaucracy should be the servant of management and leadership. It can never be the instructor.

These are intentionally broad, sweeping assertions. They need fleshing out by examining the detailed activities that fall under each heading. To maintain a deliberately sharp difference between them for the sake of clarity, assume a further distinction between the functions that management carries out and the qualities needed by a leader to ensure that those functions will work well.

THE NINE FUNCTIONS OF MANAGEMENT

The nine functions of management in an arts organisation are matched to the nine qualities of leadership. Acts precede behaviour, but behaviour will ultimately shape and determine the way actions are carried out.

Running an arts organisation is increasingly complex and demanding. There was a time when such an organisation of any size was principally about the art, with only a sidelong glance towards finance, a nod towards audiences and a moment of attention to marketing. Finance meant public subsidy, audiences looked after themselves, marketing meant a few ads in the press. Such days are long gone, unlamented and embarrassing to think about. Unlamented and embarrassing because such a limited view of the potential of these bodies undervalued, underrated and diminished the art itself, as well as the institutions housing it, and lacked any sense of its value in society. Today it is inconceivable that such an impoverished view could exist, still less prevail. The new complexity demands managerial attention to at least nine activities. If they are self-evident today, they were not so as recently as two decades ago.

First, arts managers need to know as a basic necessity about the arts for which they are responsible. Preferably they should enjoy and appreciate them not in the intense detailed way that the professionals will, but to the point of knowing that managing the arts is different in kind from, say, running a steel plant, because the final result – the product, as some persist in calling it – is quite other. Composing an opera could hardly be more different from making steel; the same is true of writing a play or creating an artwork. Managing the environment where these activities take place requires an understanding of their nature and awareness that the management appropriate to them must make allowances for that difference.

In essence: bureaucracy knows the rules and applies them; management sticks to the familiar and prefers the middle ground; leadership welcomes risk, and searches for the new.

Second, management should know about finance. It may sound odd even to have to say it. Here too the change over a generation has been huge. Financial discipline, self-discipline, within arts organisations was

too often the exception rather than the rule, as it is today. Belief in its necessity, even in its relevance in a creative institution, was seen by some as a crude intrusion into places whose prime purpose was distant from the thought of earning money. Deficits, overspends, income generation and budgetary control were regarded as concerns from hostile, culturally alien worlds, interest in which, obsession even, undermined the values of the arts being created. If the books added up – so much the better. It the books didn't balance, it was probably somebody else's fault, ultimately somebody else's responsibility. Such attitudes were common and Neanderthal, and threatened to undermine public consent for the subsidising of the arts. Such days are long gone.

Today's executive knows about the importance of finance – though the finance director (if there is one) will know more about the technicalities of the business from balance sheets to budgets. If managed well, as they should be, the organisation wins on every count. Good financial control brings a stable organisation, earns public credibility and offers opportunities for increasing income from many sources. Organisations in command of their finances are much freer to act as they need. Those constantly in debt are at the mercy of their funders. That is why finance is the second key function of management.

In summary, if bureaucracy counts the numbers and management knows the numbers, leadership understands the numbers and goes beyond them.

The third must be people – far, far more than the traditional 'personnel' function ever conceived of. Of course, the contemporary 'HR function' – 'human resources', a term that sometimes slides into the pretentious 'human capital' or the weaselly and would-be-emollient 'people' – carries the detail of pay grades, increments, terms and conditions, disciplinary hearings, sickness, stress, bullying, and a score of others. But if management knows little or nothing of the need for action on equality, gender awareness, ethnic diversity, disability and staff career development, then the 'HR function' may keep the number of references to employment tribunals reassuringly low but will be doing little or less for the coherent health, well-being and morale of the organisation.

Bureaucracy counts the people; management assesses them; but leadership values them.

The fourth management function is to handle property, capital, assets and the way the buildings work. Very few arts organisations have not had a major capital development or upgrade, or are not planning for one in the years ahead. For those working in a new building, it needs to be maintained to high standards. If not, they should be planning a housekeeping programme. Old, out-of-date buildings provide a depressing environment for visitors, limit the way in which art can be shown and presented, and project a stuffy, dowdy image to would-be audiences and supporters. Keeping the physical environment fresh, vibrant, attractive and in keeping with the aims of the organisation is a prime activity for management.

A generation ago, the fifth function of management, marketing, consisted of ads in the newspaper listings pages and perhaps the occasional season or events brochure or individual flyer for a particular occasion. Today, newspaper listings are ignored, printed material is declining or abandoned. Every organisation has a website and encourages audiences and patrons to work through online contacts and social media, from Twitter to Facebook. In this digital world, most if not all contact with the public is migrating online. It is cheaper, more immediate and creates a closer, more personalised relationship. It changes from 'one-way messaging' to something far richer – a 'two-way dialogue'. By comparison with the narrow marketing dimension of 20 years ago, engaging with the social media occupies a far larger quantity of detailed management attention; no longer a 'nice-to-have' function, it is now a 'must-have' operation, which exacts reputational penalties if handled weakly or indifferently.

As is the modern way of handling the media, the sixth function of management. Once, the 'ladies and gentlemen of the press' were just that and enjoyed a direct, close and personal relationship with the 'press office'. Together they added up to a rather secluded world, which resulted – if one were lucky – in flattering reviews, notices, encouraging previews or laudatory and even fawning celebrity interviews, all of which raised internal morale and were believed to sell tickets. It was a

straightforward transaction — arts event = press coverage = box-office sales = staff morale — which took little formal management time. In today's deeply fractured and dispersed world of communications, the press is declining, and some newspapers are dispensing with their specialist critics altogether. Now, anyone with an online presence can post his or her review of an event. Many do. Viral campaigns and communications thrive. It is harder than ever for an organisation to control its public image and reputation. Trying to do so in a world of intensely dispersed communications demands a huge degree of concentration from media professionals and management alike.

Bureaucracy doesn't see the point of marketing; management uses it to feel safe; leadership uses it to explore.

Perhaps the management function that has grown most dramatically in the last two decades is the seventh, that of 'development', formerly 'sponsorship' or, more basically, individual and corporate giving. It is impossible to overstate the importance to be devoted to this function or the resources committed to it. The 'development' activity embraces everyone in the organisation, involving the devising and operating of different levels of giving, 'cultivation' events to engage supporters in the hope of further giving, the keeping up of a regular flow of information to maintain interest, and the devising of specific capital campaigns where major gifts are needed. All of this takes up time, effort, ingenuity and commitment. Management will not succeed as management without it.

As if these did not extend the demands on modern arts management, the imperatives to act in a more commercial way throughout the organisation are intense as never before. This is the eighth function of management. It is no longer sufficient to hope to make a little bit extra on the side from bars, restaurants and souvenirs. The 'high-level' notion of 'hospitality' — formerly the low-level concept of 'catering' — has become a significant source of revenue, involving the aggressive renting out of arts spaces for corporate or commercial events. Temporarily unused spaces, whether concert halls, auditoria, galleries, bars or meeting rooms, are seen as a wasted resource if not commercially let. Such attitudes represent a huge

change of approach as major arts organisations increase the commercial contribution from their own activities and rely less on public subsidy.

Underlying every activity and offering to lead organisations in wholly new directions is the ninth function of management: technology, its use, its non-use, its abuse, its misuse. Truth to tell, there is no single blueprint for what a digitally empowered arts organisation would look like. Each one adapts technology in its own likeness. The Royal Opera and Royal National Theatre transmit productions live to cinemas around the country. The British Museum relayed an event live from its *Life and Death in Pompeii and Herculaneum* exhibition in 2013. The opportunities for using digital technology vary; so will the way each organisation puts them into practice. Every management claims to be alert to the possibilities of such change, one better understood by so-called 'digital natives'. Every management has 'technology' on its 'to do' list. Puzzling out 'what to do' demands constant involvement and will always, of its nature, be work in progress as the digital environment itself changes. But the work must go on.

Bureaucracy thinks technology could be useful; management believes it provides efficiency; leadership understands that it can change the environment.

Shouldering these nine functions in a professionalised, business-minded way has represented a revolution in the skills, outlook, inclinations and beliefs of management in the arts. By and large the transformation has taken place because of a widespread understanding that the arts could not make a serious claim to continuing public subsidy at any level without it.

But even when the nine functions of management are exercised well, is that all that needs to be done? The answer is no, because while the efficient exercise of these management functions is essential for the health and efficiency of an organisation, it will not be sufficient to make it flourish and excel, to fulfil its best purposes. For this to happen, the nine qualities of leadership are needed. They are not easy to demonstrate; every one is a challenge in itself. If the challenge is met, transformation can occur.

THE NINE QUALITIES OF LEADERSHIP

The first must be direct personal engagement with the arts. Where the leader is a fully fledged professional in his or her field – theatre director, gallery director – such engagement can be assumed, as in the case of Greg Doran at the RSC or Julia Peyton-Jones at London's Serpentine Gallery. Where the nominal leader is not a professional of this kind – a model particularly available and used in performing-arts venues – his or her passionate, if amateur, commitment to the art form must be demonstrated and apparent within the organisation. Yet no one can lead without loving and knowing the subject matter. My own background before leading the Barbican was in broadcasting and journalism, yet with the arts as a passionate hobby. Tony Hall led the Royal Opera House, home of the Royal Ballet, brilliantly for a decade, but would be the first to state that he came to ballet, and then to love it, late in life.

Secondly, arts leadership must be creative, not in the sense that playwrights, actors, artists or composers are creative but in the sense that the leader should know the totality of the organisation he or she represents, speaks up for, holds in trust and constantly shapes. In doing so, the leader transforms the ingredients of the organisation into a final whole that is greater than the sum of the parts. But this process of creative transformation and renewal always puts the values, purposes and acts of the organisation first. Creative change will only be creative if it ultimately benefits and enriches artistic endeavour. Without such awareness, it cannot be called arts leadership.

Today there is a widespread belief that leadership must be authentic (the third quality), a simple-sounding expectation that hides some real complexities. Essentially, it challenges the leader to be him- or herself. Leaders cannot pretend to be someone or something that they are not in their private selves. There must be consistency between the person experienced as the leader and the person known as the individual. Without this the leader is seen through, spotted as being fake, a sham, a mere construct or managerial convenience. If he or she cannot be trusted in this, why should he or she be trustworthy

in anything? Behind it all lies fear – fear by some leaders of revealing their real selves, hiding behind the simulacrum of what they are told by their media and marketing advisers, or so-called management gurus, that they should project. This may create an image, even for a short time a brand, but it will never last. It will never convince because it lacks authenticity.

Fourth, leadership must demonstrate passion. Without it, without feeling, without total emotional commitment, the organisation lacks spirit; without spirit there is no spark; without spark no creativity of any kind. Passion is the essential fuel of an organisation. There can be no neutrality, no moderation in the organisation of art. Running an arts institution cannot be a matter of polite indifference, ending up with something 'quite' good, 'quite' interesting, 'quite' creative. There can be no 'quites' about leading the arts. Either the end result intends to be sheerly excellent and aspires to the outstanding or it can hardly be justified. Passion infuses and informs these purposes, colours activity, enriches and energises. Unless the passion is felt from the top it will not percolate downwards.

Fifth, arts leadership must possess courage; this involves taking risks much of the time. All management practice sets the systematic scrutiny of risk as a regular activity and subject for analysis. Useful as risk analysis may be, it is only a common-sense guide to danger, not a foolproof predictor of the truly dangerous. Most arts activity – mounting an opera, choosing a new play, discovering a new artist, pushing the boundaries of the known and accepted in thought or matters of taste – is by its nature uncertain, innately risky. Many arts organisations have learned the hard way – through the box office – that the safe, middle ground of artistic policy may be middling but is not safe in cash or reputation terms. Courage to take risks without being foolhardy is a gift and an instinct. No one will follow a leader without this gift and inclination. The leader's office cannot be the residence of the eternal 'no-man' wrapped in mounds of doubt and caution. The leader's door must not carry the sign – actual or implied – 'Abandon risk all ye who enter here.'

THE MEAN SKILLS

But leadership also demands skills of a lower order. The call for courage and passion might suggest a leader with a constant, unswerving, unflinching sense of purpose and direction. Up to a point. Flexibility – the sixth quality of leadership – is often needed to keep the course and direction intact. Flexibility, especially of a short-term, tactical kind, is not weakness. It may occasionally be misunderstood, but should not therefore be abandoned as a weapon. Practised correctly it connects to the seventh essential leadership quality – cunning, especially of the strategic variety.

Showing your full hand is never a good idea in poker and seldom in leadership. Setting out a public direction is essential, but knowing when to hold back elements of that direction, to keep something in reserve, even to lay a false trail, is essential too. Strategic cunning is needed to keep an element of surprise, a fragment of the unexpected, and to keep full control of your future scenarios and intentions. It can also be fun. Knowledge is power; information is a resource; communication is a weapon – strategic cunning deploys them all. It is a vital part of a good leader's armoury.

Cunning works towards the world outside and beyond the organisation. Within it the essential quality of leadership (the eighth) is trust, not just the trust felt towards the leader but the trust the leader expresses towards his or her colleagues. It is the two-way glue that binds any organisation together. How can leadership work if it does not trust its colleagues? Why should staff work if leadership is seen or felt not to be trustworthy? Without trust of the leadership, suspicion rules; without trust of the staff by the leadership, paranoia reigns. Trust does not depend on taking easy decisions, ducking issues or fearing temporary unpopularity. With trust these can be overcome. Trust is for the good times and the bad. Without mutual trust any organisation is an unpleasant place to work in. Ultimately it is not worth working in.

It may seem odd to place the next essential quality of leadership last in this list – it is not a lower-order quality, in fact one of the highest. Leadership must articulate, express and embody the vision for the

organisation, that unifying sense of purpose and direction that any organisation of value must have. It is not a private vision defined and owned by leadership without reference to the existing values of the organisation. The leader is the custodian of the values that underpin the vision. Good leadership may tease out the full nature and strength of these values and may undoubtedly be more effective at expressing them in public. But this process depends on the humility of recognising that the values and the vision belong to others besides the leader. Values may be internalised, held almost privately, instinctively; at its best leadership releases these values to be powerful agents of action. Any leader who tries to undermine the values of the organisation he or she comes to lead, or does so without bothering to receive internal consent for the process, is arrogant and doomed to failure. But then trying to change an organisation's values from the top, expressing a vision distant from its core values, betrays trust within the organisation. No leader can make a worse mistake; too many have done.

The nine qualities of leadership are a necessary complement to the nine functions of management. Both leadership and management would do well to be supported by colleagues who possess the six characteristics of bureaucracy. These are simply stated.

Bureaucracy must be tidy, correct, observant, procedural, risk-averse and quantifiable. It should be the servant of leadership and management, never the master. Its recommendations are seldom as prescriptive as they appear. It is there to warn and advise, but never to be asked to command or consent. Above all, it must not make mistakes.

Where does this leave the two activities of leadership and management, the one allocated functions, the other ascribed qualities, and with no immediate fit or congruence between the two? The lack of functional fit only points to a direct kind of congruence. It depends on each *knowing the difference* but recognising the connections. It involves a set of distinctions deliberately defined to clarify and sharpen the point. They matter. The functions are what management must do; the qualities are those that the leader must embody to transform the way that the functions are carried out.

The three activities are separate in nature, purpose, approach and ultimately impact and effectiveness. Without this recognition organisations will not perform at their best. Applying the three-way partition to any organisation offers a useful tool of analysis. Summing it up, the qualities of leadership which make it a critical part of any institution are real, significant and demanding.

- Leadership demands understanding, the creative use of knowledge.
- Leadership reaches for originality and innovation.
- Leadership is dynamic, not static.
- Leadership shares authority rather than exercises it.
- Leadership senses the purpose and direction and then articulates it.
- Leadership embraces ideas from all directions.
- Leadership grasps problems rather than evading them.
- Leadership makes mistakes but learns from them.
- Leadership understands that being businesslike does not turn you into a business.
- Leadership is not about 'the leader'.

The deep difference from management as an activity, vital as it is, can be expressed in a deliberately extreme form: 'Management goes by the book! Leadership knows the book — and then throws it away!' And it understands exactly what it is doing as it does so. A final tableau is in order: 'Management is fearful and careworn! Leadership is fearless and carefree!'

8

WHAT DO YOU KNOW? INSIDE THE MIND OF A LEADER

'Challenge yourself as to whether you have learned.'
Clore Fellow

Any institution that receives or spends public funds for public purposes, or solicits private or public money to provide social or community services, has a responsibility, a duty, to spend it well – imaginatively, originally, dynamically, efficiently, effectively and ethically. Any such institution should test itself and its activities against these standards. The chances are that most will fail to meet all of them. This challenge affects the arts world as much as any other. It is not unique to arts bodies. But because of the high degree of scrutiny that they experience these tests are especially relevant to the arts. They should not be shirked.

Whether any public institution within or unconnected to the arts achieves success in all depends above all on the quality of leadership that it enjoys. The search for leaders who meet such performance standards is greater than ever. These standards – by the way – are not measured by mere numbers, by the formulaic and rigid demands of metrics. They are more searching than any quantifiable objectives, more important, more valuable too.

What characteristics should, must such a leader possess? For success-ful leadership is first and last about character, disposition, inclination, behaviour, outlook and attitude. Skills, of course, but even a complete

set of skills by themselves – from finance and strategic planning to com-
munication – without the vital human attributes will not create a good
leader. These essential skill sets may well be available elsewhere in the
management team of a large organisation. If not, they can be acquired by
training. It remains the leader's key responsibility to know enough of each
discipline to pick the best professionals for the organisation's core business.

Some shrink from the very notion of 'leadership', tarnished and
compromised as it has been by the ghastly twentieth-century experiences
of dictatorship, totalitarianism and the delusory goal of the 'charismatic'
leader. Some take refuge in fashionable notions of 'team leadership',
'collective leadership', 'consensual leadership', and suchlike, as if the
collective can ever really take the ultimate, hard decisions, which all big
matters involve – difficult, painful, risky, but essential. These are eva-
sions of ultimate responsibility. Society is strewn with the wreckage of
institutions that once relied on the broken reeds of 'communal' leader-
ship. The effective leader, the dynamic leader, carries forward his or her
colleagues, works with them in a commonly understood direction and
with a commonly accepted sense of purpose. Yet they will know and
accept that the final responsibility for success or failure will invariably
rest with the person at the top.

All notions of leadership and the way it is practised cannot escape
grappling with and resolving issues revolving around authority, power,
influence and hierarchy. Many approach these concepts with fear, anxiety
or instinctive repulsion. No amount of well-meaning talk about 'lead-
ing through the team' can erase these fundamental realities. Hierarchy?
Where is the organisation without a line-managed structure? Power?
Recognise a person frightened of exercising it and you will recognise
a natural subordinate. Authority? No institution can exist without its
location somewhere. It cannot be evaded, especially at the very top.
Influence? Why lead without an interest in or a wish to exert influence?

With arts organisations under financial pressure and public scrutiny
as never before, their individual and collective need to show that they
meet the key criteria outlined at the beginning of the chapter has become
critically important. The demands made of them are greater, whether

from audiences, funders or supporters. The costs of failure are greater, the imperative to succeed more urgent than ever before. No contemporary arts leader can shrink from the multiple and pressing demands made of him or her, but must programme creatively, including the new and old, the conventional and the radical, the spare and the extravagant, the comfortable revival and the unpredictable experiment. Programming cannot be formulaic.

Leaders must plan efficiently, taking into account all the expected and unexpected elements in an arts budget, the immediate and the long term, the essential and the merely desirable.

They must market brilliantly, using every instrument of persuasion, every technical device to persuade the audience to buy tickets or to offer financial support.

They must communicate persuasively, demonstrating what the institution stands for, the integrity of its values, the congruence between what it claims to be and what it does in practice.

They must negotiate skilfully, whether with funders, supporters, politicians, trade unions or colleagues and potential partners.

They must budget realistically, being honest and determined about their costs and realistic about what they can truly earn.

Above all, perhaps, they must manage generously, seeking to receive and finally receiving the loyalty, support and commitment of staff, all of whom share in a common endeavour. Such are the weighty demands made of today's top leaders, especially but not exclusively in the arts. It is not a job for the faint-hearted, the fantasist, the bully, the arrogant or the ideologue. But the leader does have a task, a responsibility, a duty and even a mission to reconcile the multiple and sometimes conflicting demands that he or she should fulfil.

So what balance should leadership strike between these conflicting demands? It must be strategic by nature but capable of acting tactically by calculation, strong as a lion but cunning as a fox, risk-aware but not risk-averse, liked but not popular, friendly but distant, hard-working but not possessive, committed but relaxed. The person at the top knows that the public garlands for success often go to others; the brickbats for

failure will be directed at him or her alone. What will determine success or failure? It is the manner in which he or she behaves, in which his or her personality and temperament address and handle complex demands.

FOUR REASONS FOR LEADERSHIP

Of the four reasons that leadership is in urgent need in present circumstances, the first is most simply put, a plain statement of fact, of everyday reality. The arts world is more complex than it used to be in what it does, more ambitious in what it is called upon to do and expected to be more publicly responsible – usually called accountability – for what it does in the public interest and usually with considerable quantities of public money. Until some 20 years ago, it was sufficient for the leader of an arts organisation to provide the very best events, plays or exhibitions possible; other matters were either a lower priority, an incidental activity or simply not seen as part of life. Put very bluntly: 'Do the arts and the rest will follow if it matters.'

Second, it follows that leadership recognises that providing the highest quality of arts is merely the start. Doing so triggers a long trail of activities that are now integral to the arts programme rather than ancillary or discretionary. These include education, outreach, widening access, harnessing technology, linking to the neighbouring community, creating partnerships, liaising with stakeholders, forging international relationships, harmonising with higher education and being deft and canny with politicians, national and local. It is a big agenda, one that has grown inexorably.

Third, it matters that the leader should understand the size of the stage on which he or she must operate, accept it, gear and equip him- or herself to fulfil its demands successfully and, above all, welcome the range of opportunities that this agenda brings. Arts leadership is a huge practical task and a very complex one too.

Finally, it matters next that the arts leader should accept that such a task will only be carried out successfully if he or she behaves in a way that is active, dynamic, self-questioning and competitive. Armed with a lively

awareness of why circumstances have changed to make arts leadership both more essential and more demanding than ever before, the leader must be endowed with or develop aptitudes, inclinations and instincts that complement the essential skills that he or she must possess. Knowledge is important; character is vital. Leadership is about behaviour; how does the leader sense how he or she needs to behave?

THE SIX SENSES

To be successful, the effective leader should possess six key senses. They cannot be taught; they may be often painfully acquired; if they are neither learned nor respected their absence could be terminal.

First, it should go without saying that a sense of vision is a basic attribute of a leader. Any organisation should possess and own the big picture of what it stands for. The leader will search out the pre-existing vision in the place and among the people that he or she leads. He or she may well add to it, fine-tune it, shape it, possibly even refocus it, but must first understand why an arts institution needs a vision, why it will usually possess one, however internalised it may be, and why the leader's job is to articulate publicly what the institution believes in and about itself. At the British Museum, the director, Neil MacGregor, personally defined the mission of that institution as being a museum 'of the world and for the world'. In a phrase, he expressed for the staff what they did and why they did it, and gave the world beyond a compelling understanding of why the museum existed.

Second, a sense of direction is needed through which the vision is realised. A more practical instinct, it is an essential attachment to the more abstract, highly coloured imagery of the vision. Getting down to earth to turn the great picture into actual reality involves a clear idea of where to go. Dreaming dreams, painting pictures is not enough. The long journey starts with a sense of direction.

Hard on its heels comes a sense of purpose, a deeper level of activity that turns the previous senses into specific reality, the determination which understands that detailed, hard work is needed on a daily basis

to achieve the grand dreams. It involves specific, often small steps, exact actions informed by the sense of direction. At the Barbican in the late 1990s, devising new arts programming, renovating and renewing unsympathetic spaces and managing the staff in ways that handed over responsibility rather than demanding accountability took years to achieve. All of these things were informed by a sense of purpose, a determination that the Barbican would become a major international multi-arts centre.

Fourth, the leader must articulate a sense of identity, and be aware that it must be both understood and shared; without it, an organisation fragments and breaks up. An organisation should feel and believe that it is special, different, possibly unique. It must feed off and own its sense of identity.

Part of this feeling of being special flows from the leader's ability to provide the fifth key sense, that of cohesion. This does not require an imposed uniformity, a centralised model of behaviour, an insistence on standardised modes of behaviour, rather the reverse. It is the benevolent opposite, allowing difference in practice, variety in creation, diversity in action, all existing within the prior sense of the cohesion owned by everyone. One of the keys to Tony Hall's successful leadership of the Royal Opera House, Covent Garden was his ability to bind together the previously warring interests of opera, ballet and the new commitment to original work in a new sense of shared identity and purpose.

All of these senses will be more difficult to realise without the essential sixth sense, that of feeling. No body of people can work without feelings, about themselves, their work, the place and the people they work with and for. Without feelings of contentment, satisfaction, fulfilment and self-respect, why should anyone work to his or her full capacity? The leader must sense the difference between the times when such feelings are met and satisfied and the times when they weaken or wither. Above all, the leader is entitled to have his or her own feelings, should be ready to show them and should insist on his or her right to have them, but must understand that they will be satisfied only when those of everyone else have been.

THE FOUR ANTITHESES AND APTITUDES

At this stage some of the complexities involved in leadership begin to fall into place. Everything understood and absorbed in this process of self-analysis, of developing self-awareness, must be infused with the reality that leadership operates within a framework of antitheses. They could be paradoxes, they might appear to be contradictions, but their polarities offer fertile grounds for exploration. Taking the four antitheses of leadership to heart opens up further layers of understanding. It is a given that true leadership is not dictatorship. The antitheses stem from this starting point. The leader must and will express authority, a commingling of the authority provided from the institution and the personal authority that any leader should possess. Yet that authority must never be confused with acts, words and behaviour that look or flirt with being authoritarian. The leader must decide, must be the final point for decisions to be taken. Yet that responsibility for being the end point of a process is informed by a duty to listen and be informed before taking the decision. The leader must have beliefs and convictions, must know what they are. Without them, he or she would be merely a sponge for absorbing the beliefs of others. A sponge cannot lead.

Equally, having beliefs and convictions does not carry an imperative to be a 'conviction leader', one whose own beliefs dominate others. The wise leader understands that the strength, utility and effectiveness of his or her own beliefs will be supported by backing from and respect for the convictions of colleagues. As will be seen below, the third antithesis recognises that the effective leader will take risks and does not fear risk. But he or she is not and never should be foolhardy. Taking risks is always tempered by prudence. Proper prudence is never confused with the elimination of risk.

Much discussion of leadership concentrates on the importance of skills. They are important but inevitably lean more to the managerial side of leadership – qualities that are necessary for leadership but not sufficient for it – rather than to those less tangible but essential qualities that are ingredients in the mix. These less tangible qualities are expressed in the

notion of the four aptitudes of leadership. They represent a further step along the road to understanding that if a leader cannot manage contradiction, cannot unpick paradox, cannot face uncertainty, his or her life in leadership will be unhappy and short.

The first aptitude involves achieving the necessary balance between the short term and the long term. A great deal of leadership activity – whether in politics, business or the arts – involves deciding which is which and accepting the fluctuations in classifying where decisions lie. Can leaders spot the difference between the two? Do they understand when they are dealing with one or the other? Do they know how to make each occur in the order that they want and need? Do they understand how the short and long term interconnect? Do they have policies and programmes in which the successful delivery of short-term objectives helps towards the achievement of – or may threaten to obstruct – long-term goals? Are some leaders actually more at ease dealing with the short term because the long-term vision is, well, rather distant, uncertain and a bit frightening? A moment of clarity – there is nothing wrong with the 'short term'; such aims and goals are important and valuable. Momentum is maintained in this way. But do such immediate goals also lead to the successful long-term result? Do they pave the way? The two – short term, long term – must connect and play off one another. But habitual 'short-termism', representing a mere reflex, a policy perhaps amounting to an evasion, is an abrogation of strategic leadership. We can all recognise the symptoms in politicians; the dilemma is as acute in the arts.

The second aptitude requires a deal of personal understanding and self-awareness. How does the leader calibrate his or her instincts between the polar opposites of patience and impatience? Necessary impatience, perhaps even a divine impatience, is a rich and valuable quality in a leader. Without it, cautious conservatism, inertia or stagnation take over. Reasons can always be provided for deadlines to be missed, objectives to be omitted, once bold ambitions not to get off the ground. The leader has a right to get ratty at such failures, to question why something once agreed has not been achieved. If they are not occasionally – and even deliberately – ratty, no one else will be. Impatience starts at the top. Unless the leader

shows this characteristic, no one else will feel that they should. From this point of view, the leader may well risk appearing like 'the person who cares too much'. That is a risk worth taking. But the leader should certainly want to be defined as 'the person who cares most'. Impatience forms part of that caring. It is not mere irritation.

For patience also has its place, especially when it recognises that no great change will be achieved quickly or at once, and that the first small steps – provided they are the right ones – are those that lead in the right direction and to the right goal. Change in institutions takes time. Being impatient with the pace of change may be counterproductive. Knowing when to accept comparatively slow development with patience and when to kick it hard for being laziness in disguise is an essential quality and skill. In my own experience at the Barbican in the late 1990s, it took at least four years before there was a feeling of real progress on the artistic policies that we were seeking. There were many setbacks and disappointments on the road.

What is crucial is the constant interplay between two apparently quite contradictory aptitudes. Patience and impatience are but two sides of the coin. Each has a role. The rewards come when each is understood as a tactic; their use is a skill, a crucial means of shaping responses to fluctuating needs and priorities. The leader in thrall only to one or the other will be a lopsided and unbalanced leader driven too much by emotion and instinct rather than a blend of instinct and reason.

The third aptitude concerns the way in which a leader responds to the opportunities offered by taking risks or the damage caused by failure. I make no apology for emphasising such apparently 'soft' characteristics. Much of arts leadership involves such qualities; it will not succeed unless they are possessed and used. This does not mean that leading the arts involves a lack of discipline, rigour or concentrated purpose. It does mean that the so-called 'soft' characteristics can only be effective if understood and applied in an ordered way. Empathy is not sentimentality; feeling does not eliminate discipline; understanding does not supplant skills.

The ability to choose between risk and failure is one of the most important aptitudes that a leader can possess. No one can or should play safe

all or most of the time. There's no upside in risk elimination, no margin for the rewards of success. But risks must be measured, weighed and calculated – and when they remain marginal, that's when they should be taken. Leaders must always know what the risks are. Being unaware of risk or indifferent to it – especially reputational risk – is unforgivable and usually exacts a harsh penalty – from the leader. But taking risks is not the same as being rash or foolhardy or reckless.

Failure of itself is not necessarily bad and is certainly not a terminal condition. Failing to meet an objective – now incorrectly regarded by some as a hanging offence, in the managerialist lexicon – is nothing of the kind. A target missed may have been the wrong target in the first place. All the masters of good management insist that junking an objective that has not worked is not a sign of failure but rather an indicator of strength, flexibility and speed of response. 'People, this isn't working!' is a strong message, not a weak one. Admitting to and recognising failure allows a fresh look at the original target and a decision that a totally different direction may be needed. Admitting to failure and starting again is good. As Samuel Beckett said: 'No Matter. Try Again. Fail Again. Fail Better.' (I have Tom Phillips' wonderful print bearing those words outside my study door.)

There is one further aptitude that digs even deeper into human personality – the 'optimism/pessimism' indicator, the 'glass half full/glass half empty' test. In most respects this is easy. No one wants to follow a pessimist. Pessimism is for the private moment. If you want to be a pessimist, don't expect others to follow. If you are instinctively gloomy, an Eeyore type, the permanently melancholy donkey from A.A. Milne's *Winnie-the-Pooh* stories, do not try to be a cultural manager. Such types worry too much and make everyone else miserable into the bargain. Habitual pessimism helps nobody. A good leader, even a good manager, must be an optimist, like A.A. Milne's Christopher Robin. Though perhaps he is just a hero!

A.A. Milne's books are not just for children; rather they are for children but their wisdom quietly prepares the child for the experiences of life in adulthood. The extended family that is represented in A.A. Milne's nursery world offers a perfect model for the well-balanced management team

in the world outside. Pooh Bear represents the cuddly, warm, generous person whose instincts are right and whose failings – love of honey – are forgivable (the creative director). Tigger is the bouncy enthusiast, the doer who occasionally crashes into other people but whose energy is priceless (marketing). 'Wol' – the Owl – is very wise, very serious, very knowledgeable, but can miss the point (finance). Rabbit is eternally busy with his long list of objectives to meet but needs direction (premises management). Kanga is the mother figure, warm, enveloping and understanding but dispensing a firm and reassuring discipline (human relations). Embracing them all is Christopher Robin (the chief executive), to whom everyone turns, everyone loves and around whom – ultimately – most things revolve. Christopher Robin is the person who cares the most, but his first care is for his family. This model is not about leadership by sentimentality; it could be leadership by understanding and character.

It underlines the fact that good leadership combines an understanding of the things that matter, the senses required, the antitheses to be overcome, the responsibilities to be undertaken, the aptitudes to be possessed. These qualities involve deep personal self-knowledge and true discipline. They involve feeling and emotions. These may not count as skills in the narrow, conventional sense. Yet without them skills alone are arid things. Their possession will prove more valuable than the most well-stocked toolkit. Leadership is about what you do; what you do depends on how you feel; how you feel depends on who you are. For many this will take some facing. But it is the heart of the business of leadership.

9

AN ARTS POLICY FOR A FLOATING UTOPIA

'I am attracted to things that are impossible.'
Clore Fellow

It is not every day that you are invited to draw up an arts policy for a new state. That is what happened when the artist Alex Hartley first identified and then brought into being a new national entity, a small but real piece of solid earth, an unregistered island, discovered in the High Arctic on 19 September 2004. Tickled by the thought of an emerging piece of territory, Hartley decided to see if he could take control. Seven years later it sailed into international waters when it was officially declared a new nation. This was more than an artist's conceit, though probably only an artist could have imagined it. Hartley then proceeded to endow it with the attributes of statehood. He began by enlisting citizens – 23,003 people from 135 countries took citizenship. He engaged volunteer ambassadors and, of course, set about creating a set of policies.

It was not only an amusing game, a pleasant squib, a way of testing notions of statehood, identity and all of the trappings of those things. Starting with a clean slate, could this new statelet create an identity that supported policies and behaviour that were in some respects an improvement on the common run of such matters in the wider world? Alex Hartley called this new state 'Nowhereisland', which parsed in three ways: the declaratory 'Now Here Is Land', the

minatory 'Nowhere Is Land' and the bleak 'Nowhere Island'. Yet like all good utopias, 'Nowhereisland', however parsed, is real enough and gained its own artistic reality every day. It was a blank screen on which to write of the ideal.

Alex invited me to draw up its arts policy. This was too great a challenge, too rich an opportunity to ignore. I had no inclination to dodge it. It was also a temptation to dream, setting to one side the routine preoccupations of the arts world and launching off into realms of imagination and fantasy about arts policy, yet remaining rooted in reality. Thinking about 'if only' smoothly turns into 'what if?' Moments later those ideas transform into the reasonable but demanding 'but why not?'

So this was my response to Alex Hartley's invitation. In the following terse phrases I set out to make good all the shortcomings, eliminate all the evasions, confront all the contradictions, overturn all the circumlocutions that have accrued over, encumbered and finally vitiated all government arts policies. I was deliberately ambitious. I hope it is worthy of the clean sheet that the existence of 'Nowhereisland' permitted, even demanded. I was lucky enough to be spurred into it by a specific suggestion. I recommend the exercise to any arts leader seeking release from the heavy bounds of earth and office. What would your ideal arts policy be? What would you really wish your own arts policy to be? What is the arts policy you dare not put into words? This was mine.

- No child will be denied a full education in the arts.
- Every child will be read to each night.
- Every school day will start by singing songs together, hymns if they wish.
- Every child and young person will be able to learn a musical instrument to the stage where he or she can – if he or she wishes – play in public or with others in private.
- Every education establishment will base its teaching on the knowledge and belief that the arts benefit learning.
- No child or young person will be told that 'the arts are not for you'. The arts belong to everyone.

- Every child will have the opportunity to look, learn, listen and make.
- Every pupil will learn about the historic traditions on which contemporary arts practice is based.
- Every teacher will be qualified to communicate enthusiasm for and knowledge of more than one art form.
- No school or educational establishment will divide its teaching into either the sciences or the humanities. There is only One Culture and each reinforces the other.
- Every child will have time in the curriculum to do nothing and learn how to be bored.
- All higher education and all arts venues will integrate their learning and performance activities.
- All government policy will be based on the assumption that healthy and vibrant communities are centred around the arts.
- All government policy will address education and the arts in the same department.
- No government will regard the arts and education as the mere workhorses of business and commerce.
- No government will tell education and the arts that they should be 'like businesses' or even 'more businesslike'. All governments will acknowledge that the arts and education run themselves in ways that are relevant for their disciplines.
- All arts organisations will accept full responsibility for running themselves efficiently and effectively.
- Every arts organisation will have one or more representative from business on their governing board. Every company will have one or more representatives from the arts and education on their governing board.
- Government will set a strict cap on how much arts organisations can spend on management consultants.
- No arts organisation will set out its aims and priorities in PowerPoint presentations which consist of bullet points only and exist without verbs, complete sentences or full stops.

- No arts organisation will use in its Vision or Mission Statement words such as 'excellent', 'passionate', 'leading' or 'world-class', or any other word, phrase or notion derived from management speak.
- No arts or education establishment will regard, treat, deal with or otherwise think of its audiences or students as 'customers'.
- Every arts and education body will officially proclaim and announce that its activities are fundamentally and intentionally useless. They will ignore and disregard any request or demand to demonstrate that they are useful before they are valuable or that they have measurable 'impact'.
- Government will declare that the true impact of intellectual and academic research and the pursuit of curious enquiry may not add immediately to the national economy but will contribute to national understanding.
- No arts body will be funded if it declares its aims and purposes to be primarily instrumental.
- Arts and education bodies will not be asked to demonstrate the 'relevance' of what they do as a condition of funding.
- Every elected representative will spend at least one night per week at an arts event or performance of some kind.
- No prime minister will avoid attendance at arts events on the grounds that he or she might court unpopularity by doing so. On the contrary, he or she will earn it.
- No prime minister will attempt to court voter popularity by claiming to like current pop groups when in truth he or she does not listen to them.
- Any prime ministerial contender may like and enjoy football if he or she chooses. But it will not be a condition of his or her selection for high office.
- Every government will ensure that those who give money or objects to the arts in their lifetime receive the benefit of tax concessions in their lifetime.
- No minister will refer to the arts as 'elitist', 'irrelevant', or merely 'nice to have'.

· No Secretary of State for the arts shall be precluded from becoming prime minister.

The drift of my policy should be clear. It binds the arts and experience of them into education, learning, community and society. It recognises the arts as an intellectual and social force for cohesion, curiosity and conviviality. It undermines the humbug of populism that so many politicians affect. It offers liberation from what I call 'arts-shame' and 'culture-fear', two conditions rife in the political air. It is open, tolerant and free. It exists to be improved and built on.

Does that amount to a future agenda for the arts? If it was good enough for 'Nowhereisland', it is surely good enough for our own dry land. If we all allowed ourselves to dream these dreams of policies to be, some of them might change the world. It would not be painful.

10

KEEPING IT SIMPLE

*'Relationships with governments are like sticky
rice — they shouldn't be overcooked.'*
Taiwanese arts academic

*'Experience without concept is a mess; concept
without experience is a nightmare.'*
Anon., Asia

Sometimes the best response to complex problems is to revert to simplicity. It is not a flight from difficulty, rather a calm awareness that occasionally dawns after hard thought and tussling with the seemingly insoluble. Such a drive towards the simple is available to leaders in all activities — from business, to academe, to government, to the arts. My own journey has been in and through the arts. I believe that reaching back to the fundamental, to the simple, is an act absolutely relevant to anybody running anything. If in doubt, strip it back.

Recently, in Hong Kong, I sat in an all-day conference on cultural leadership in Asia. I wearily reflected that at four p.m., after a whole day of presentations, questions and discussions, I would have to sum up the entire event. This occasion followed four intensive days of retreat mulling over the same topic with future arts leaders. Everything to be said, surely, had been said! Every complexity, every intricacy, every inconsistency had been identified, held up, scrutinised, exposed, qualified, rejected, validated and occasionally understood. We were talked out. I was drained. What could usefully be said that would add to what had been — often wisely — said? Suddenly in the intensity of the seminar, I found myself turning

to simple thoughts and observations. This had been a useful exercise on other occasions. Might it work now?

For instance, as I outlined earlier (see Chapter 5), as part of the ongoing struggle against the rigidities of managerialist nostrums, I have reformulated them in common-sense ways. Thus what was 'policy' becomes 'What do you want to do?' What was 'vision' becomes 'What is your idea?' And so on. This approach to simplicity could sweep away obfuscation and professionalised pretension. It might liberate and return power and control to those willing to use it. All of these activities are not necessarily easy in themselves, but I believe they are much harder when dressed up in pseudo-conceptual language that is not designed to achieve results.

Adopting this approach at the conference, might I find an equivalent moment of clarity emerging from the welter of ideas, stories, claims and positions thrown up by the seminar? What was cultural leadership about anywhere? Was it different or likely to be different in Asia or, come to that, Africa or Latin America? In the minutes before summing up, I found myself reflecting on things said and thoughts stimulated in the preceding hours. A tired and overloaded brain then conducted a severe process of reduction to these essentials, under the heading 'Keeping it Simple'. This is how they emerged.

- 'If it's no good – it's no good.' The first, last and only condition demanded of art of any kind is that it should be good. It really is that simple. Any suggestion that invites belief that work in the arts can be justified if it is 'quite good', or perhaps that art in certain conditions or special circumstances may be acceptable so long as it is 'good enough for the job', must be pushed to one side without apology. Nor should it expect an explanation. It would not deserve one. There is only one criterion of justification, that of excellence.
- 'If you want to do good – be good.' This amounts to an admonition to those who use the arts in one way or another to deliver social or economic results. Their activity is an important part of the whole spectrum of ways in which the arts contribute to

society beyond their prime activity of performance or show. But their contribution socially or economically will only be as effective as it could be if it is excellent art first. This should be blindingly obvious – often it isn't.

· 'If people don't trust you – they won't come.' Much time and effort is spent on wooing audiences, holding them, persuading them, informing them, keeping their loyalty. All such effort is wasted if the organisation at the heart of the relationship does not deserve the audience's trust. This shifts the question away from relations with audiences to the prior and more profound one of the nature of the organisation itself. Unless it is, and is perceived as being, honest with itself and therefore trustworthy, all ancillary activity towards the audience will be vitiated. Put your own house in order first.

· 'Tricks are tricks – not answers.' Every organisation has problems. Where possible these should be addressed and solved. Solutions are hard to come by and may be untidy or partial, but could still be as good as you can get. Many organisations fool themselves that outsiders – usually in the form of consultants – can find perfect or near-total solutions. They are not solutions but merely tricks. The tricks look clever and seem to offer completeness. They seldom do. Recognise them for what they are.

· 'Don't try to fool the public – you fool yourself first.' Self-deception starts at home. Everybody else sees it first. The first act of self-deception is not to know that others recognised it before you did. It leaves you looking very foolish – and others know it first.

· 'If you put lipstick on a gorilla – it's still a gorilla.' Don't pretend that superficial change is anything other than superficial. Do not be fooled by appearances, by cosmetic changes. They mask but also reveal an inability to make the real changes needed. Besides, lipstick always wears off.

· 'Relationships with governments are like sticky rice – they shouldn't be overcooked.' Don't get too close to the authorities or stay around them for too long. Overcooked sticky rice is an

indigestible, unpleasant mess. Excessive proximity to government clogs you up too.

· 'Experience without concept is a mess; concept without experience is a nightmare.' This was starting to stray from the deliberately simple. But I let it through. How should you combine the value of learned experience with the sustained thinking that makes the experience useful and start to approximate to wisdom? Unexamined experience is an undifferentiated mass. Some theoretical framework is needed to refine and order it. Those who start with the certainty of theory but have no experience on which to base it create deformed ideological monsters. If experience comes first, the practice of theoretical examination can turn it into something useful.

I still find some comfort and reassurance in this response of simplicity. It felt like a relief from complexity, not an attempt to avoid thought. The fact that it was inadvertent suggests the working of the subconscious. Reaching for simplicity needs time; it needs space; perhaps it needs tiredness too. But it may also reveal.

Part II

Arguing for the Arts

11

THE STATE OF THE ARTS, THE ARTS AND THE STATE

From the Barbican to the Conservative Arts
Task Force — August 2007 to April 2008

> *'[In our household] no child has ever picked up an
> instrument and most forms of culture are considered,
> by the male members at least, as being "for losers".'*
> Fiona Millar, partner of Alastair Campbell, Tony Blair's press adviser.

Having ceased to be managing director of the Barbican Centre in 2007, my engagement in debates about the arts continued. There was no reason to stop, no reason to stand back as if my interest in or involvement with the arts had waned once I left the Barbican. Fortunately a variety of invitations to debate and contribute has given me the opportunity to range widely over major arts issues in the period since then. This, the second half of the book, contains a selection of those contributions in the form of the texts of speeches made by me since leaving my Barbican post. In this chapter I reflect on New Labour's tortured evolution from a position in which they didn't 'do the arts' to one in which they cautiously embraced the notion of 'excellence'. In Chapter 12 ('Music all around us') I address the amazing range of human benefits and social and political good that the arts provide. Chapter 13 ('The education debate: Giving the young the arts they deserve') examines the importance of connecting with the

past as an essential ingredient in the creativity of the present. Chapter 14 ('The arts: A special case for special pleading') proclaims the need to be fearless in arguing for arts funding as a case of unapologetic special pleading. In Chapter 15 ('The arts and civil society: Firm friends or distant cousins?') I puzzle over the disconnection between the arts world and that of civil society – the voluntary sector – despite their myriad elements in common. I conclude in Chapter 16 ('Small is significant: Taking care of the roots') with an attempt at a coherent argument for the value of the arts to the nation.

Some themes emerge: the need to make a strong, courageous case for the support of the arts using language that belongs to the arts and not to the world of business (see also Chapter 5); the extraordinary lack of connection in theory, awareness and practice between areas of intellectual and creative activity that should have everything in common – such as the arts, civil society and universities; and, perhaps most crucially, the decade of political and theoretical struggle between New Labour's 'instrumentalist' agenda and the arts world's refusal to be bullied out of a fundamental belief that excellence must come first. I return to this engagement in different ways in more than one chapter because of its crucial importance in understanding the last decade and a half of arts politics and policy.

But what emerges strongly, is usually under-reported in the media and is under-recognised by politicians, civil servants and ministers is the range, variety, energy and ingenuity of the arts at all levels across the UK. Most debate – too much perhaps? – about the arts emphasises the role, funding and functioning of the major arts institutions. Given the scale of financial support they attract this is on one level not surprising. But to ignore or overlook the incredibly widespread range of arts activity down to the smallest, most distant or most socially needy communities is to conduct an incomplete, even broken-backed, debate. These chapters attempt to set that omission right.

Each chapter in this part of the book is prefaced with personal reflections of how I viewed the arts scene at the time. Many are drawn from a contemporaneous journal setting in context the principal

public controversies that raged over everything from principles to funding. In taking this approach, it does not attempt to be a definitive chronicle of the major arts disputes of the period but rather an impression of the mood in the sector at the time seen through one pair of eyes – my own.

I left the Barbican in July 2007 with a decent but not overblown sense of fulfilment. Proud as I was with what I, the arts director Graham Sheffield and my senior colleagues had achieved, I had an almost equally strong sense that the scene I left to Nicholas Kenyon, my successor, was littered with tasks uncompleted, tasks unaddressed and certain stubborn problems that had simply defeated me. But it was time to move on. The City of London Corporation, the Barbican's owners and funders, had put up with what they wryly called my 'obstreperous ten-point emails', my insistent awkwardness in speaking up for the Barbican's artistic and operational needs and my frequent public clashes with and direct criticism of the Arts Council. The corporation's elected representatives and officers were in truth remarkably tolerant of me, though that tolerance did wear dangerously thin on more than one occasion. For my part, I was diverted by the corporation's displays of public vanity and overt self-satisfaction. But I greatly admired its political skills, its adept public manoeuvring and the deep sense of public duty of an almost old-fashioned kind that made it the third-largest supporter of the arts in the country. None of us at the Barbican ever took that for granted.

Those 12 years were now behind me. What would follow? I remained very involved in the arts scene. I had recently acted as independent chair for the Conservative Arts Task Force at the invitation of the shadow culture minister, Ed Vaizey. Initially my employers, the City of London Corporation, were reluctant to allow me to take it on, fearing that it threatened what they saw as their universally recognised political neutrality! I persuaded them that the risk to the corporation's reputation was small, that my personal independence was widely understood and that to prevent me from joining the task force in my closing months as

managing director of the Barbican Centre would seem an ungenerous recognition of services to the City of London in the previous 12 years. Permission duly came with many corporation anxieties attached, all of which proved duly unfounded.

The turn of the year – 2007–8 – was very active. The Labour government's comprehensive spending review in October provided modest relief for the arts, with a settlement that was level in 'real terms' – it allowed for inflation. But the culture secretary, James Purnell, was able to lob in some welcome additional goodies – a further £50 million for Arts Council England and an additional £30 million for museums.

Controversy, though, was not far off. It engulfed both of the country's major arts-funding institutions – the British Council and then the Arts Council. In August 2007 the former appointed a new director of arts, Venu Dhupa, who promptly declared she was 'not here to do arts. I am here to do cultural relations. If you want to do arts for arts' sake then go and work for the National Theatre.' That was clear enough, and the roof duly fell in on her and the council. Dhupa tried to explain that she saw the arts as a 'strategic transformational force because that's when they are at their most powerful.' Few understood what she meant. Artists such as Rachel Whiteread responded matter-of-factly that 'if you take the building blocks away you lose the foundation', a simplicity of expression beyond the concepts and vocabulary of the cultural theorists, a view shared by many artists.

New Labour had decided that it needed to fashion a new approach to the arts, beyond the doctrine of the crude and defensive 'instrumentalism' of their early years, and commissioned Sir Brian McMaster, former director of the Edinburgh Festival, to chair a review. McMaster and Alan Davey – in his previous civil-service incarnation – daringly worked in tandem to rehabilitate the notion of 'excellence' as a guiding objective in the arts while wisely avoiding specific definitions. But just using the word 'excellence' was enough of a signal. Despite this, politicians were still in two minds about whether they approved of the arts and whether they could afford to show their interest in them – wasn't the newfangled 'excellence' just the dreaded 'elitism' dressed up in flowery language?

The Arts Council, flush with the generally warm reception given to the McMaster report in January 2008, ran into its own trouble as it allocated specific funding from the spending review to individual organisations. Some theatre organisations lost funding altogether; the theatre world hated it, culminating in Nicholas Hytner's exasperated comment: 'A hell of a lot of people in positions of power and influence don't just believe the bollocks, they live the bollocks. They complicate rather than simplify.' It was left to the incoming director of the Arts Council, Alan Davey, to try to pick up the pieces, to offer reassurance and emollience and to say: 'We've got to rebuild our credit [...] One of the things that hurt me a bit was that we were portrayed as a lot of faceless bureaucrats.' It took Davey a while to convince the arts that neither he nor 'his' Arts Council behaved so crudely. He did point out that the anger over specific funding decisions sprang from the 'most far-reaching review of public funding in the history of the Arts Council'. He promised that the Arts Council would be 'confident in its judgements, well informed and big enough to listen and learn'.

The Tories too were active in preparing for the political debate – or were they? At a dinner in Dover Street in London's West End early in April 2008 as a thank you for the work on the Tory Arts Task Force, the shadow culture team of Jeremy Hunt – future Secretary of State – and Ed Vaizey were present. What emerged was that the Tories in opposition had a very low opinion of both the Arts Council and the British Council. The discussion moved against separating sport spending from arts and culture spending, but considered ways of stopping further raids on the arts budget by the Olympics. The overall mood was strongly critical of the Arts Council – its present reduced size reflects the mood of five years ago – but was bullish about easing tax concessions on lifetime gifts, which only made the botched attempt in the 2012 budget to restrict concessions on charitable giving seem even more incompetent.

Jeremy Hunt said that the forthcoming Tory arts policy in the autumn of 2008 would draw on the task force's report. In the event it did not do so. During those months I often asked when and how the report would

be used in Tory policy making. I never got a satisfactory answer and it was never used in any substantive way.

Sometime previously, a Liberal Democrat arts spokesman asked me informally – with doubt in her voice – if I would have chaired an equivalent task force for them. She seemed surprised when I replied: 'Of course!'

As professional musicians debated these matters at their annual conference, the question of singing in schools was raised. One teacher lamented the inconsistency of government understanding of schools' and children's needs as reflected in the National Singing Programme initiative. 'It has no folk music in it; are they frightened of connecting children with their own folk heritage? In any case, the songs have a lot of very easy syncopation, which ignores the fact that kids are listening to far more sophisticated music on their own iPods!' I suggested that schools should revive school assemblies and the singing of hymns. Why? Great tunes, harmless words and opened lungs. I point out that public schools flourished on starting each day with two 'openings' – first the bowels, then the lungs. Or, put more catchily, 'first the bowels, then the vowels'. One Jewish music teacher said he had insisted on joining in his own school's 'Christian' assembly because he would not be excluded from the great Anglican Victorian hymn-singing tradition.

These were diversions, though valuable enough in context. The real issue was: what was New Labour up to before the banking crash overwhelmed us, before real and long-lasting austerity prevailed? It was time to combine my thoughts on the connections between the McMaster report and my Tory Arts Task Force. What did they have in common? Were they in truth pulling in the same direction? On 8 April 2008 I attempted an answer by considering and examining these two reports on the arts in a speech to the annual conference of the Incorporated Society of Musicians (ISM), held at Buxton. It turned on a single theme: the return to excellence.

THE RETURN TO EXCELLENCE

I have been randomly collecting press articles about music – there is nothing systematic about it, but an almost arbitrary accumulation of writings, issues and stories can be revealing. Lack of system does not mean lack of purpose. The random is the real. It should not be dismissed or taken for granted. What is important is the great deal of attention the world of music gets from the media, though not always in the ways expected. But does it reveal anything, does it add up to anything?

For instance, in December last year, many thought, dared to hope, that nirvana was approaching. Every schoolchild, according to the education secretary, Ed Balls, was to have access to five hours of cultural learning and activity every week. This looked a grand offer, almost a new deal for cultural learning for the young.

At the risk of carping, it needs fleshing out. What kind of culture, what sort of learning, what type of activity? And, inevitably, what will it cost and have those costs been funded? If the answers are still awaited, it is sad to report that first indications about the money actually available are not reassuring. If nothing else, the Balls announcement prompted a reminder: when a politician comes appearing to bear gifts – like the ancient Greeks – demand to see the colour of the money.

In January this year, you could read of a new Taser stun gun – the one the riot police use to control violent crowds without shooting them. The latest model – beyond its incapacitating electrical charge – was to have an MP3 player and earphones built in for the comfort and convenience of the user. While this displays an admirable concern for the sensitivities of the deployed police, pause for thought is required. What tracks will be loaded onto the MP3 player to assist as a diversion while fighting off an assailant or subduing a violent crowd? How ever did law enforcers keep their calm and sanity without such a facility? Such sensitivities should go further, taking into account the style and design of the Taser in the hope of its becoming a fashion must-have.

In the same month, the violinist Tasmin Little announced a striking innovation: her new album, *The Naked Violin*, would be available for free on her website. Tasmin's justification was characteristically feisty and almost recklessly provocative: 'I want to prove once and for all that the only reason why people don't sample classical music is that they don't have open minds, or they are lazy.' Neither felt like a very attractive category to find yourself in. But the impulse behind the offer remained attractive. Still in January – an active month – news emerged of the so-called 'Yellow Lounge' in Berlin. DJs spun classical discs as video artists projected 'edgy' images on adjacent screens. Later in the evening the Mahler Chamber Orchestra played a set – Schumann's Violin Concerto and Mozart's 'Jupiter' symphony. The music was familiar; the setting and the categories were different, crossovers from another genre. It seemed to add up to a classical rave, an oxymoron, a paradox or an outright contradiction. The British violinist Daniel Hope joined up and joined in: 'It's fantastic to play in a room full of young people who will listen to John Cage and Xenakis.' Would someone in London follow suit?

In February, Sir Harrison Birtwistle collected a British Composer Award in the Instrumental Solo category. He could not resist saying something pointed and relevant as he received his prize: 'There are thousands of children out there who don't know what music is; for them only music which has a drum mechanism with it is music.' Would anybody really listen to what he was saying? In 2006, after being presented with the classical-music prize at the Ivor Novello Awards, Birtwistle asked the assembled pop musicians: 'Why is all your music so effing loud?' It is a serious question. Has anyone given a reply, plausible or otherwise?

In March, London caught up with Alex Ross, music critic of the *New York Times*, whose daily blog was enthralling readers with his response to and discovery of anything and everything from the classical to the most current and innovative. He was not, he insisted, attempting to lay down a new set of musical orthodoxies, a historical reference list of approved and accepted masterpieces. 'I'm not trying to manufacture a canon,' he said, 'I'm just offering a lot of possibilities and openings. It's the whole

mechanism of the link; it's endless.' Which amounted to an admirably open-minded and undogmatic approach.

Daniel Barenboim's survey of the Beethoven sonatas at the Royal Festival Hall during January and February of this year became a huge public event. In 1999, Barenboim had also used his immense artistic reputation and position of authority to try to influence the tragic politics of the Middle East through the creation of the West-Eastern Divan Orchestra, composed of both Israeli and Arabic musicians. In December last year, Barenboim complained, when one of his Palestinian musicians was banned by Israeli security forces from performing in a concert, that 'a baroque music concert in a Roman Catholic church in Gaza [...] has nothing to do with security'. Some barriers are too great for even music to overcome. Barenboim never stopped trying.

Classical music walks on the fragile eggshells of British class sensitivity – mightily powered by social guilt – not because of what it is but what it is presumed to signify. When, for instance, the Labour MP Margaret Hodge attended a classical music concert in London, she appeared to be more interested in whom she was sitting next to, the class and social composition of the audience, than the music being performed. In March Hodge, then culture minister, gave a speech in which she attacked the Proms for being out of touch and unrepresentative. This was too much for the great cellist Steven Isserlis, who raged in a letter to the *Guardian* against 'the mindless twitterings of people' – he had Hodge in mind – 'who understand absolutely nothing about music'. He added: 'She wouldn't dare attack a concert by a rap artist for failing to appeal to the vast majority of British listeners for fear that it might lose her votes.'

These random gleanings – and there were more, many more, in the first months of this year – create no unified pattern but do provoke one thought. Who ever suggested that the musical world in one of its many forms isn't central to people's lives? It is all around us. The danger is rather of it being taken for granted.

What cannot be taken for granted is the economic and policy environment in which all in the musical world work. Over the last six months, decisions have been taken, policy directions set and new suggestions

made about the arts that will influence and even reshape them dramatically. Three events in particular raise issues of the highest importance: the government's public-spending announcements of October 2007, the government-commissioned McMaster report and the Conservative-commissioned Arts Task Force, which I chaired.

The results of the government's public-spending review were announced in October 2007. For months beforehand, artistic blood had run cold with ever more threatening warnings of cuts to come: 'Prepare for 5 per cent off everything,' was one of the less alarming. 'Or possibly 7 per cent!' The arts world, to its credit, refused to be intimidated, hung together, argued back and made a strong case not only for funding to be at least maintained but for the absolute value of the arts to be recognised. 'Being good' – or 'delivering excellence', as it would probably be called – was held up as the best reason for maintaining funding, not as something to feel guilty or apologetic about.

Following the spending review, Arts Council England actually came out with a 1.1 per cent increase over inflation over the next three years. The DCMS's own capital allocation for museums and galleries was increased by 147 per cent in cash terms, a figure magnified by vital support for major capital schemes for both Tate Modern and the British Museum. In the circumstances, there was relief all round. It was a 'we can live with that' sort of settlement.

But in another part of the landscape things were getting darker, with cost overruns on the 2012 Olympics leading to a loss of £121 million of formerly 'arts-directed lottery funding', now diverted to sport. Since most of those funds had previously been directed towards smaller arts organisations, the diversion of funding damaged more modest arts organisations disproportionately.

Yet the 2007 public-spending settlement was important, the first building block in the scene in which the arts will live for the next three years. First, there was an actual increase in Arts Council core funding. Second, the collective persuasive powers of the arts community, effectively marshalled, had had a real impact on government decisions. Third, the Treasury at least nodded towards the possibility that the most valuable

effects of the arts could not be measured – this meant that they did not have to prove that they were principally instruments of economic growth or social change. Finally, the new Secretary of State, James Purnell, signalled the possibility of a new sensibility towards the arts. The spending round would be less 'prescriptive' – there would be less telling arts organisations what to do – and would be based on a few headline priorities rather than scores of objectives and targets, which he rightly termed 'targetolatry'.

THE MCMASTER REPORT: THE WIND OF CHANGE

So the financial framework was settled. What sort of policy framework would it support? This question was partly answered by the McMaster report when it appeared in January 2008. Commissioned by Secretary of State James Purnell, who came out of the process rather well, it gave a clear view of what government intentions and policies towards the arts would be at least until the end of the parliament.

Though the report will always be associated with Sir Brian McMaster, another person deserves recognition for his role in delivering it. For at least a year before the report appeared, Alan Davey, in his capacity as director of arts and culture at the DCMS, had been privately lamenting the fact that the Arts Council seemed not to understand the importance of values in the arts or of the need for excellence in what the arts did. It seemed more concerned with what it called 'outcomes' of an incidental, albeit associated kind – did the arts improve education, increase social cohesion, advantage ethnic minorities? – than with the overriding need for the arts to be excellent in themselves. It was a dreary commentary on the extent to which some in the arts had adopted the expectations and objectives of others, a kind of intellectual capitulation.

The McMaster–Davey inquiry signalled clearly, if signals were needed, that a huge change of policy was in the air. After all, for the better part of the previous decade, the policy language that emanated from New Labour's DCMS was filled with the language of management speak – objectives, outcomes, deliverables – aiming at results that had nothing directly to do with the arts. The arts were not valuable in themselves – it was held – but

were valuable and fundable only if they were instrumental in achieving other ends. The arts, in other words, were simply, or even principally, instruments of the state's social and economic policies.

With the report heavily trailed in advance, McMaster's title said almost all that was needed: *Supporting Excellence in the Arts: From Measurement to Judgement*. In the foreword, the Secretary of State, James Purnell, threw down the governmental gauntlet. 'The time has come to reclaim the word "excellence" from its historic, elitist undertones and to recognise that the very best of art and culture is for everyone.'

The change of tone and line was remarkable. After all, the only people who had used 'excellence' as an elitist boo-word were New Labour themselves and their own outriders. If reclamation of the word, the idea, was needed, then it was from Labour's own side. Still, the word had now been reclaimed, revalidated and properly restored to its place as the paramount criterion for judging and valuing the arts. Interestingly, in the glossary of terms at the back of the report, the word 'excellence' was not defined. But in his own conclusion, McMaster called for a 'more confident articulation of the concept of excellence – from government and funders to artists and cultural organisations'. It was a reasonable call. If we in the arts world wouldn't or couldn't shape robust definitions of our own, then someone else would step in and produce some very tendentious ones.

The report received a broad welcome but raised many questions. The group National Campaign for the Arts did indeed want rather more of a definition of the term 'excellence' and was rightly anxious about a timetable for putting it into practice. Local-authority representatives were worried about the idea of taking artistic risks – 'The right to fail is a very hard one to sell to councillors.' And they saw no reference to the idea of community. Another local-authority voice feared that a fixed idea of excellence could reinforce a 'culture is not for us' mentality. The independent cultural think tank Mission Models Money thought McMaster did not recognise the complexity of the issues he addressed and was alarmed by what it called the 'language of the patrician old school of "gatekeeper"'!

The Tory shadow arts minister, Ed Vaizey, attacked it as a rather bland, woolly document, combining hubris with bathos – quite an achievement!

What was less well noticed was the comparatively small but pointed reference in the report to the role of television in creating an audience for the arts. As McMaster wrote:

> The decline in the provision of cultural programming through the public-service broadcasters is an issue that few can have failed to have noticed, and I believe that it has been to the detriment of public understanding of the arts and the depth of engagement in cultural activity.

Aimed at the BBC, this barb was well made and a necessary reminder of the dwindling of the corporation's historic role at the centre of British cultural provision.

In this context, writing in the *Guardian*, the television director John Wyver noted that channel commissioners demand that a programme establish total understanding with the audience in the first 30 seconds, in order to prevent viewers from zapping to another channel. Wyver noted approvingly McMaster's observation that 'too many organisations are trying to second-guess what their audiences want and are therefore cheating them out of the deepest and most meaningful experiences'. To some that might be called risk; to others it looked like the exercise of professional judgement.

The upshot of the McMaster report was that notions of 'excellence' were re-established, 'instrumentalism' was put back in its box and a new, wider agenda for policy to the Arts Council was indicated.

Yet McMaster was far from perfect and probably received a much softer press than it deserved. Many of the less-reported recommendations were dubious and some questionable. For instance: 'I recommend that innovation and risk-taking be at the centre of the funding and assessment framework for every organisation, large or small.' So without risk-taking, without innovation, was there to be no funding? It could hardly be that simple. As a prod to adventure the recommendation may have been useful, but it was far too sweeping in its prescription.

Then McMaster continued: 'Funding bodies and arts organisations

[should] prioritise excellent, diverse work that truly grows out of and represents the Britain of the twenty-first century.' Important as the practice of diversity was, could it truly be given the priority that was suggested? Essential as involvement in the world around us was, should a dominant commitment in arts activity be given to the work of the twenty-first century above that of preceding ones? It was in danger of sounding facile.

McMaster roamed further afield: 'The Arts Council, the British Council and the Department for Culture, Media and Sport must work together to investigate and implement an international strategy.' This was a very bad idea. The Arts Council should have been encouraged to do its work nationally far better than it did before it spread its wings internationally. And the British Council was finding considerable difficulty at the time in defining precisely what its own international arts strategy should be in any case. Perhaps an international arts strategy for the UK was desirable, particularly in the context of the so-called 'soft-power' debate, but for the present, its outlines remained sketchy.

Next: 'I recommend that the board of every cultural organisation contain at least two artists and/or practitioners.' This sounded attractive, but having sat on boards where this applied, I must puncture that balloon. Whether an arts board works well or badly is unrelated to the presence on it of artists and practitioners. So-called 'suits' – business people and other professionals – were quite smart enough to work out that they were advising an organisation that was not a business but had to be businesslike. In practice, artists on boards often found it hard to make financial decisions that might inevitably lead to artistic dilution or even compromise.

Finally, the McMaster report contained a weird recommendation: 'Funding bodies [should be] involved in the appointment processes of the organisations they fund'! This was a strangely bad idea, one that would lead to a degree of intrusion into the managerial responsibility and independence of the organisation – and funding bodies are not managerially responsible. I have had direct experience of how this recommendation works in reality. In one major instance, our funders heartily endorsed a very senior appointment. When it proved to be less than a resounding

success, the funders very publicly disclaimed any responsibility for their part in the decision. Good governance is not made of such stuff.

THE ARTS TASK FORCE: ANOTHER VIEW OF THE LANDSCAPE

The McMaster report followed that of the Arts Task Force, which was published in October 2007 after having been commissioned by David Cameron as leader of the opposition. I and my colleagues on the task force were less concerned with high principle, valuable though that was, and more with how the arts could be better run. Above all, the task force made no calls for increased funding – that would have been both too easy and too predictable. By examining operations and practicability, we offered a different and additional view. We called it *A New Landscape for the Arts*.

First, how should central government actually run the arts? At the DCMS, we suggested separating sport from the arts. They are ill-assorted bedfellows, with sport – especially the Olympics – always pinching the bigger share of the blanket. We argued that this inbuilt bias against arts funding has to stop. Some argued that this would make the department too small to warrant a seat at Cabinet, but we suggested that it could be strengthened by having the creative industries attached to it, a neat and necessary fit. Whitehall 'plumbing', the reshaping of departments in the light of evolving priorities, is important.

We also believed that the department – in its new form – should have direct responsibility for the national 'regularly funded organisations' – the major performing-arts houses. The objection to this appears to be that this would abolish the cherished so-called 'arm's-length' policy. Nobody ever explained why the national museums – the British Museum, the V.&A., the National Gallery, the Tate – can deal directly with DCMS without losing independence, and the equivalent performing-arts institutions cannot. In reality, if the national museums were asked if they would rather have an intermediary body – such as the Museums, Libraries and Archives Council (MLA) – managing their contacts with government in order to provide so-called 'arm's-length' protection, they would run screaming.

Such a structural change at the top would immediately impact on the nature and role of Arts Council England. Some might say it is about time. Any organisation capable of dreaming up the notorious Clause 22 in current funding-application forms – the need to declare the 'gender inclination' of the members of the applicant body – surely has an incipient death wish. Despite that, the Arts Council, we insisted, has a role to play.

All the evidence the task force heard suggested that regional arts councils do a good job. We believed that the branch of the Arts Council dealing with London should behave more like its fellow regional councils, which, once the major performing institutions were removed from their control, they could do. The outer London boroughs, for instance, badly need an injection of thinking about arts provision. (At the Barbican, I had launched an initiative to take the institution and its programming out to the outlying London boroughs, a scheme I called 'Barbican Without Walls'. Sadly nothing came of it.) Apart from anything else, the London-area Arts Council's record of contributing positively to any of the recent crises affecting the major institutions has been, at best, patchy.

The task force argued that boards of trustees and governors should suffer less meddling from government – especially about their composition, length of appointment and functions. They are, after all, legally constituted bodies, supposedly independent and regulated by the Charity Commission.

We encouraged local authorities to play a bigger role in supporting the arts. This should have been easy given the interest local authorities have in creating and fostering a sense of community, something at which arts provision is particularly effective. The best route to achieving this, the task force argued, is not by making it yet another statutory obligation as such but by including support for the visual and performing arts as a significant part of the 'culture bloc' – the technical term for the way local authorities' efficiency and effectiveness is measured. Local authorities care deeply about the grading they get in these assessments. As things stand, the local-authority 'culture bloc' includes sport, swimming, leisure and parks, but not the arts in any recognisable form. In fact it is possible for a local authority to offer no performing or visual arts at all but still be

rated as effective in providing its 'culture bloc'. The nadir of this approach was reached when the City of London Corporation, sole funders of the Barbican Centre, once received a low score in its 'culture bloc' assessment. Despite being the third-largest funder of the arts in Britain, the corporation scored low on swimming pools and parks. What idiocy!

The task force argued that Gift Aid needs to be drastically simplified and the Treasury's puritanical aversion to giving donors the tax benefits on their charitable gifts in their lifetimes has to be overcome.

In education, we believed that what is taught and learned about the arts is as important as what can be experienced from taking part in arts activity. We observed that the benefits of digital technology to the arts are still imperfectly understood and that many organisations need help and advice in ways that they can harness technology to their needs, whether in attracting and keeping audiences or in finding new forms of creativity.

Such were the landmarks in the *New Landscape for the Arts* that we set out for the Tories. They were severely practical. Most cost no money. Most could be put into practice very quickly.

What was less noticed was that the McMaster and task-force reports are not antithetical documents. They are complementary – they fit together. Taking the broad philosophical approach from McMaster and the detailed practicality from the task force, the bones exist of a very good arts policy: joined-up, broad-ranging, coherent and practical, with a strategic vision and a tactical awareness. What might it all add up to?

Firstly, a restructured DCMS, with more culture, less sport. Ministers should end their obsession with the idea that sport is popular with everyone – especially the Olympics, which were popular – and that 'culture' isn't. The Blair–Campbell New Labour administration famously did not 'do God', but neither, apparently, did they 'do' culture. They and their successors might reap unexpected rewards if they 'did' what they believed in.

Secondly, a restructured Arts Council England, concentrating more on the regional and on ways of harnessing technology, and offering more advice on how to maximise tax benefits – an Arts Council of many small things rather than huge projects. The overriding concept might be of an Arts Council as strategic enabler rather than as fussy supervisor.

Thirdly, local authorities that take on board the opportunity offered by encouraging the arts. Costs are involved, but they might find there are rewards for the community too. Lastly, a tax regime that rewards givers in their lifetime rather than acknowledging them only when they are in their grave. These could be the features of a new landscape for the arts.

But it can't all be left to the politicians and civil servants. What is left for those of us in the arts to do for ourselves and on our own behalves? There is no room for passivity or inaction.

Too often, many involved in the arts and humanities – both as practitioners and as academics – have spoken about their fear of marginalisation, the pressure on their resources, the poor understanding of their role and purposes. An air of defeatism leading to neglect or outright hostility is colouring what they feel and have to say.

There is only one observation and one lesson. The defeatists are the most likely to be defeated. A daft government policy will become a daft reality if no one says it is daft. Daft policies are put forward by civil servants – with two eyes and two legs – and politicians similarly equipped. They do not know more than anyone else. They are not cleverer than people in the arts world; often they know less. What they propose or even demand is often a mere try-on rather than reasoned policy. Treating it like unchallengeable tablets of stone will only concede defeat. It would be a surrender signal. Consultation, challenge and contradiction are the stuff of debate. Give them up and you surrender the only weapons you have. The arts do it too often. And they face some unbelievably negative attitudes.

Fiona Millar, the partner of Tony Blair's former press secretary and later director of communications, Alastair Campbell, recently gave the game away. Reviewing a book in the *Guardian* about so-called 'hyper-parents', those competitive people who would do anything to make their children great, Millar confessed to having been a short-lived, would-be hyper-parent herself. She believed, she hoped, that playing Mozart CDs to her unborn child might turn him or her into a violinist. She gave that up. But Millar's review continues:

It is now a family joke in a household where no child has ever picked up an instrument and most forms of culture are considered, by the male members at least, as being 'for losers', especially when the alternative is a good night in watching sport.

This attitude, close to the heart of New Labour, is worth examining. She only played Mozart because she wanted her child to be a success, not because his music might be richly valuable, even enjoyable, in its own right. Furthermore, if you need an explanation for the Blair government's attitude to the arts, there it is. Culture is 'for losers'. Straight from the Downing Street couch. Such attitudes should have been impossible to parody, but weren't.

The rest of us will continue to bother about the arts. Why? Because it matters: to us and to large numbers of people everywhere. Let's never forget that. We will continue to stand up for what we believe in, for what we know is good, especially when the attitudes questioning us are so negative. We have a lot to lose if we don't.

12

MUSIC ALL AROUND US

From the Chairmanship of the University
of the Arts London to the Clore Leadership
Programme — April to November 2008

*'The twenty-first century is in danger of being the first era in
history to value mass mediocrity and water-cooler chitchat
over individual genius, expertise, courage and leadership.'*

Richard Morrison, *The Times*

The middle six months of 2008 saw the pattern of work for my next five years become established. At the outset, I was getting into the saddle as chairman of the court of governors at the University of the Arts London (UAL), a federation of six formerly independent London art colleges – Central Saint Martins College of Arts and Design, Chelsea College of Art and Design, Camberwell College of Arts, the London College of Communication, the London College of Fashion and Wimbledon College of Art. At the end – in October – I was appointed by Dame Vivien Duffield's Clore Leadership Programme to succeed Lord (Chris) Smith as chair.

Taking over at the UAL had not been without its complications. Shortly after agreeing to become chairman in 2007, I had been invited to apply for the chairmanship of the trustees of the V.&A. Both after all were non-executive, part-time positions. Together they seemed to offer the possibility of a very good, varied and stimulating working life after 12 years of

full-time executive work at the Barbican. After the usual interviews, I was offered the V.&A. post and accepted happily. However, it soon turned out that the UAL governors, whom I had consulted beforehand, had become very anxious. They feared that I would become more closely associated with the V.&A. – a historic and highly prestigious institution – than with the fledgling university that was the UAL. They anticipated conflicts of interest over sponsorship and development in particular, and put their anxieties to me openly and without rancour. It was clear to them as our conversation developed that my holding two such posts would be more than inconvenient. They thought it untenable.

I recognised their anxieties and promised to think it over and make a rapid decision for everyone's sake. The following morning, I phoned to say I would stick to my commitment to the UAL, which I had accepted first. I would therefore resign from chairmanship of the V.&A. Both the V.&A. itself, in the person of the director, Mark Jones, and the DCMS, in the shape of Alan Davey, took it incredibly calmly and in their stride. There was neither reproach nor recrimination. If there was puzzlement, they kept it to themselves.

What was amusing was the reaction within the arts world. Some saw no problem in holding both positions, perceived no conflict of interest and could not see why giving up one of them was called for. But if that was my decision, then that was my business. Others insisted that high-level arts politics had been at work. I had been 'forced out', according to the more lurid versions in circulation, by the Secretary of State in person. No amount of personal assurance that the decision was mine alone satisfied the practised conspiracy theorists. For them life could never be that simple. But it was. I never regretted the decision, not because I wanted to give up the V.&A. before I had started but because involvement with the UAL proved so satisfying.

These satisfactions included appointing a successor to Sir Michael Bichard as rector (later titled vice chancellor). Nigel Carrington came from a distinguished career in the law and business; the governors judged that anyone who had managed a huge firm of law partners like Baker & McKenzie would understand many of the problems of leading academics,

and so it proved. Together we moved the university to the point of committing to a massive new campus for a united Central Saint Martins at King's Cross. This confirmed my long-held view that any chairman had three tasks to accomplish in order to ensure a quiet life: choosing the right chief executive – done; getting a major building project right – almost done; and keeping the finances on the rails, which it was clear Nigel Carrington could and would do, and he amply did.

In the summer of 2008, the nearby development at Kings Place opened its doors. A visionary mixed development on the banks of the Regent's Canal at King's Cross, it was the achievement of a Newcastle property developer and arts lover, Peter Millican. Not content with an elegant canal-side commercial building designed by the architects Jeremy Dixon and Edward Jones, Millican insisted on including a 420-seat chamber auditorium, sweetly elegant in sound and appearance. For some weeks this project seemed in danger of confusing relations with the long-established Wigmore Hall, where I was still chair of trustees. Some in the music world – never slow to see rivalry brewing – chose to predict inevitable conflict between the two halls, perhaps over public profile, musical repertoire and performers and artists. In practice every hall in the music world guards its roster of artists with care, counting on their loyalty over a long or emerging career to keep them and their agents on side. Equally, no single hall should be the unique gatekeeper to fresh and emerging talent. As to the repertoire, our view at the Wigmore was that the chamber-music and song repertoire was so huge that the possibility of damaging duplication between the two halls was highly unlikely. And Kings Place's location made it a natural and inviting venue for audiences in north London and beyond. In short, whatever the short-term rumblings might be there was certainly room for two fine chamber-music halls in a metropolis the size of London. So it has proved.

There was a further thought. The music world is very competitive, unsentimental and even ruthless. I reflected that when the Queen Elizabeth Hall was built on the South Bank a generation previously, the universal assumption had been that Wigmore Hall would be driven out of business by the competition. Nobody argued for special protection for Wigmore

because of the huge sentimental attachment to it for its history. Were it to fold under its new rival from across the river on the South Bank, then that was life. Wigmore Hall fought back using its own skills and resources and flourishes to this day. As does Kings Place.

The big arts world continued to intrude on my life. The Arts Council was seeking a new chair to succeed Sir Christopher Frayling. On 8 August, out of the blue I received a letter from the DCMS. It was odd. It invited me to apply for the vacant position of chair of Arts Council England because their 'database' showed that I was interested in that sort of thing – a curious form of wording, I thought. A good deal of bumf was attached, which I read attentively. Objective eight pulled me up short. It said that the chair would ensure that the council would pay 'due attention to guidance from the Secretary of State'. At a stroke, it seemed to me, the 'arm's-length' principle on which the independence of the arts in Britain had existed for 50 years had been undermined and replaced by the new, Persil-strength, 'arm's-length-with-ministerial-guidance-added' principle, a very different proposition.

I felt so strongly about this that I wrote a piece for *The Times* explaining why such political 'guidance', inevitably shading over into 'obedience', would produce the wrong, no, disastrous, results. The notions of independence exercised with responsibility were more mature and would ultimately prove more effective. A week after the publication in *The Times*, another oddity occurred. Despite publicly ruling myself out of any contention for the post, I was called by the headhunters conducting the search, who had been asked to canvass my views by the DCMS. I observed that for the Arts Council chair to be credible with the arts world he or she must be 'of and from' the arts and experienced in practical administration. He or she must be independent of government and not be or seem to be a ministerial postboy or -girl. Above all he or she must distance him- or herself from some previous Arts Council regimes who combined the worst of weakness, bureaucracy and complaisance in their dealings with government. Soon after, Dame Liz Forgan was appointed chair and made such a good and independent fist of it that – four years later – the next Tory Secretary of State, Jeremy Hunt, did not renew her appointment.

At the end of October, I was offered the post of chair of the Clore Leadership Programme, with Sue Hoyle as director. It was the start of an immensely rewarding six years of working with the next generations of arts leaders, activity whose demands fitted comfortably with those of the UAL.

The seismic plates of the arts were shifting. In September 2008, the first outlines of the 2012 Cultural Olympiad were announced, leading the National Theatre's Nicholas Hytner to hail them optimistically as an 'unprecedented opportunity to confirm London as the world's cultural capital'. The new chief executive of Arts Council England, the former civil servant Alan Davey, felt emboldened to issue a friendly challenge to the politicians when the organisation launched its three-year plan, *Achieving Great Art for Everyone*. As Davey put it:

> My message to politicians – keep up the spending on the arts and do so with confidence and purpose. Include us in any schemes to expand or bring forward public expenditure or to help those engaged in cultural enterprise. Be imaginative, engage with us.

If that was hardly a rallying cry, it was a shrewd appeal couched in terms that were familiar to him and were part of the accepted Whitehall dialogue. But then as a highly experienced former civil servant, Davey knew how to calibrate his tactics.

Such were the high-level exchanges about the future of the arts. In the non-metropolitan world, the daily round of the arts of every kind and every level continued. It was easy to overlook or take for granted the incredible multiplicity of ways that music affected and impinged on our everyday lives – why were politicians so confused in their responses to the quotidian activities of the arts, their influence and their potential? Perhaps Alan Davey's pointer towards the notion of 'engagement' – in more senses than one – was even more relevant than it seemed. It was these ideas that I explored in a speech to a public audience at the University of Kent in Canterbury in November 2008.

———

THE BACKGROUND SOUND TO THE WORLD

Is Britain a society especially beset by the binary, the world of 'either/ or', habitually dividing everything into black or white, sheep or goats? Can you be interested in music without being classified as a 'musician'? Speaking as an absolute musical amateur, I learned the piano to the age of 18 – with difficulty – and sang heartily in the school choir. That was where proficiency began and ended. It was time well spent. For, on this basis, music became one of the most important parts of my life. I like, admire and respect professional musicians. But there was something particular about those for whom music was a hobby and a passion. Where would the musical world be without the amateurs, the lovers of music?

Another truth. Lovers and practitioners of music come from every intellectual school and discipline. This immediately confronts the great British education myth – or curse – that at the age of 16 every young person is and should be herded into one of two great corrals: the humanities or the sciences. The separation is bad enough in itself. It carries with it the often explicit instruction to stop being interested in the other great category of learning and to cease expecting to understand it either. Binary classification, the 'either/or', the sheep and the goats, struck again.

In the nineteenth-century English public-school system, lovers of sport and its character-building values were either lauded as future heroes of the imperial battlefield or reviled as 'flannelled fools and muddied oafs'. The artistically inclined could be satirised by Gilbert and Sullivan as 'a greenery-yallery, Grosvenor Gallery, foot-in-the-grave young man'. Once entrenched, it became a ludicrous 'either/or' approach to life, a barrier to shared human experience as pernicious as the worst rigidities of the money and class system.

THE PERILS OF POPULISM

One of the reasons that politicians fear being seen as personal supporters or willing funders of the arts stems from this ancient, rigid division. It

might explain why, when asked about their favourite music, they almost invariably choose a pop or rock band, as Gordon Brown embarrassingly did when he opted for the Arctic Monkeys as a personal favourite. Whose real voice was that, whose beliefs? Surely not the master of the financial universe, the saviour of the global monetary system? You could hear the Brown's political spin doctor breathing: 'You must be seen and heard as populist or the voters won't accept you.' This is a modern version of the pact with Mephistopheles, which never ended well. The likelier truth is that voters back people who are honest, who sound like real people, are unapologetic about what they like and are comfortable with who they are.

Honourably, Nick Clegg, the Liberal Democrat leader, proudly told the composer Michael Berkeley in a recent edition of BBC Radio 3's *Private Passions* that he had been introduced to classical music by his German teacher at Westminster — the legendary Richard Stokes, who also taught the great British tenor Ian Bostridge — and then choose Schubert's song 'Der Erlkönig' to prove it. Clegg might have other problems, but a lack of honesty about himself does not appear to be one of them. Though some thought his response reflected a political calculation too.

These should be universal assumptions. Music belongs to the many, not to the few; it is not a restricted, secluded practice and discipline but something that appears in the most unexpected, unpredictable places. Public evidence suggests that this is indeed the case. Those places stretch far beyond the confines of the university, the conservatoire or the concert hall. That is one of music's enduring strengths.

For instance, it is no surprise that Elgar's most solemn moment in his 'Enigma Variations', 'Nimrod', carried a special resonance for mourners at a funeral or indeed any public occasion with special gravity attached to it. But there were others for whom the sound of 'Nimrod' had a still more special meaning: the elephants in Belfast Zoo. Unsurprisingly, university researchers discovered that elephants did not respond well to captivity. Signs of stress included swaying, pacing, trunk-tossing — all familiar enough to any zoo visitor, possibly part of the enjoyment of watching them. But once serious music was played to the elephants, Elgar's 'Nimrod' or even Puccini's 'Nessun dorma' from *Turandot*, a very

different kettle of musical fish, the beasts calmed down. The Belfast elephants proved broad-minded in their musical responses. Researchers solemnly recorded that 'the elephants don't seem to have a favourite composer'! But the conclusion was that playing them some classical music did indeed calm them down.

Human beings have been found to respond to classical music in places far removed from the concert hall. Any listener responds strongly to the irresistible swaggering march of 'Dance of the Knights' from Prokofiev's ballet *Romeo and Juliet*. Most can hardly fight down the urge to stride a little longer, stand a little taller, stare a little harder when it is played. It was intended to have a special impact on Sunderland Football Club as they marched onto the pitch for a home fixture. But with Prokofiev's march blaring from the loudspeakers there was another intention in mind – to undermine the visiting opponents. Sunderland's recent form might cast doubt on the value of the experiment, but its significance is that it was attempted. Football clubs have been very inclined to such musical stimuli as performance motivators. Take Fulham. Even the famous chorus from 'O Fortuna', part of Carl Orff's *Carmina Burana*, has been caught blaring through the Craven Cottage loudspeakers on *Match of the Day*.

There are further cases of the use of musical therapy of an unpredictable kind. Are there more seductive, beguiling, lulling pieces of music than Frederick Delius' 'Walk to the Paradise Garden'? Yet one of the train-operating companies decided to cheer up passengers on some of its quieter and more remote stations by playing Delius through the loudspeakers. It was a pleasing gesture. Did it work? The evidence was that playing Delius did little for passenger morale, but in an unanticipated consequence crime and vandalism at the stations in question did fall. It drove away the vandals, an unforecastable consequence. This might, though, count as a result of a kind.

Proposition one from such deliberately anecdotal evidence is that classical music, broadly defined, is more publicly pervasive than customarily assumed and is harnessed by people and in places not normally to be expected. The power of music should never be underestimated or undervalued.

THE FESTIVE GLUE

Proposition two is that classical music has a further value because it is intensely social: it marks out the calendar, it celebrates the great landmarks of life, it allows people to unite in sharing such occasions. And its use in these social ways is very unpredictable. Where might Tchaikovsky's *Nutcracker* ballet be forecast to represent an essential part of the festive season? With its Christmas trees, sugarplum fairies, tingly music, snow-tinted windows, it reeks of northern Europe from St Petersburg to London. Yet the citizens of Miami, Florida, have appropriated it as their seasonal own. The sun is insistent, the heat oppressive. The connection between Tchaikovsky's winter fairy tale and acres of oiled and tanned human hide in the Florida sun is far from obvious, but it is impossible to move theatrically in the sunshine state without tripping over a *Nutcracker* during the festive season. The only possible explanation is that everyone uses music to construct the associations and connections that they want and need.

With slightly different nuances, the Japanese cannot mark the new year without a performance of Beethoven's 'Choral' symphony. Many Britons need to experience Raymond Gubbay's *Mozart by Candlelight* during the 12 days of Christmas. There are no rules and regulations for making and enjoying such connections. Community and togetherness are triggered by the most unexpected sounds. Classical music is recognised as being available for these instincts. 'Music hath powers to soothe the savage breast' — it has had for several centuries. It is known to have the power to lower blood pressure. One day, perhaps, it may even be found to lower cholesterol levels as well.

If such remains in the realm of fanciful speculation, simpler truths are beyond challenge. Research has shown that singing is good for health. In a 2001 study, 87 per cent of respondents from a university choral society said they benefited socially from singing in the choir; 75 per cent said they benefited emotionally (romantically, perhaps?); 58 per cent referred, rather vaguely, to the physical benefits they derived from singing.

Further research identified no fewer than six areas in which singing provided physical or psychological benefit. They were: well-being and

relaxation; breathing and posture; social significance; spiritual significance (probably shortage of oxygen); emotional significance (see above); and benefit to the heart and the immune system. While these observations are in a sense agreeably imprecise, it would be very surprising if such a communal and physical activity as singing did not make its participants feel better.

My own experience at school at Gresham's in north Norfolk certainly supported many of these findings. Every morning except one, the entire school trooped into chapel for a story, a hymn and a prayer. Whatever your feelings about the story and the prayer might or might not have been, the hymn was rousingly good fun even in the deepest, most self-pitying throes of adolescence. At a national conference of music teachers I suggested that schools would benefit hugely if they restored to the daily timetable a morning assembly where hymns were sung. To the entirely predictable objection that this might be offensive to non-Christian children, the reply was that no one took the words seriously as theology, that everyone was stirred by the tunes, and that no one should be denied access to time-honoured classics such as 'Abide with Me' or 'Eternal Father'. Of course 'Onward, Christian Soldiers' might prove difficult for other faiths, but why should anyone be deprived of the tune? These responses to music were a part of deep social interactions.

Two heads of school music stated that they did include a morning hymn as a regular part of the school's life and vouched for their effect on the school community's well-being. Another music teacher observed: 'I am Jewish, and was excused Christian assembly at school. But I insisted on attending as I wasn't going to be denied those hymn tunes.'

Sadly, such positive attitudes cannot be taken for granted, either about singing in particular or classical music in general. In the BBC TV series *The Choir: Boys Don't Sing* in February 2008, the charismatic, irrepressible choirmaster and vocal Svengali Gareth Malone took on the challenge of a school where absolutely nobody sang, either formally, informally or in any other way. (A handful of boys did sing in their private lives in church choirs but they never spoke of it, as if it were a matter of secret shame.) Gareth Malone's aim was to revolutionise the school environment to the

point where everybody sang, including the PE and sports teachers. Gareth's nadir in the series – for he always has one – came with the blank, hostile refusal of the senior sports teacher even to contemplate the possibility that he might join a choir. The look on his face indicated his feeling that he was being lured into some sort of morally degrading group activity.

There was a happy-ish ending when a school choir and a teachers' choir did sing – pretty badly – at a school open-day event. But they did sing together and quite enjoyed the experience. The underlying question of how any school, anywhere, in contemporary Britain, could exist with no collective music-making at all remained lurking in the near background, unquestioned, unexplored, unaccounted for. How could any local education authority allow it to happen, a school without music, a subject overlooked, abandoned, rejected?

A very different kind of community music experience was charted in the documentary *El Sistema* about the extraordinary impact of mass classical music education on the children of Venezuela. It was in the summer of 2007 that the BBC Proms audience had been electrified by the appearance of the Simón Bolivar Youth Orchestra of Venezuela, children of the 'El Sistema' music programme. Would it be yet another internationally roving youth band, very worthy, quite interesting, but not very distinctive? By the concert's end, when the huge band attacked familiar classics with a vigour, an exhilaration, a sense of raw rediscovery and a musical quality that took the audience's breath away, the answer was clear. The Simón Bolivar Youth Orchestra was something special.

It wasn't only that the bass players twiddled their 'bull fiddles' like a demented Jack Lemmon in Billy Wilder's *Some Like It Hot*, that the trumpeters twirled their instruments around their fingers in joyous circles – the Simón Bolivar Youth Orchestra stood for an idea, a philosophy. The underlying vision was that if you give children – now 250,000 of them – instruments, teaching and the chance to play in groups leading to playing in a full orchestra, you will create good musicians; you will offer an alternative to the hopelessness of drugs and pimping on the streets of the slums where many live; they stand to gain skills, self-respect, personal and social standing that nothing else can offer them. Eyes had